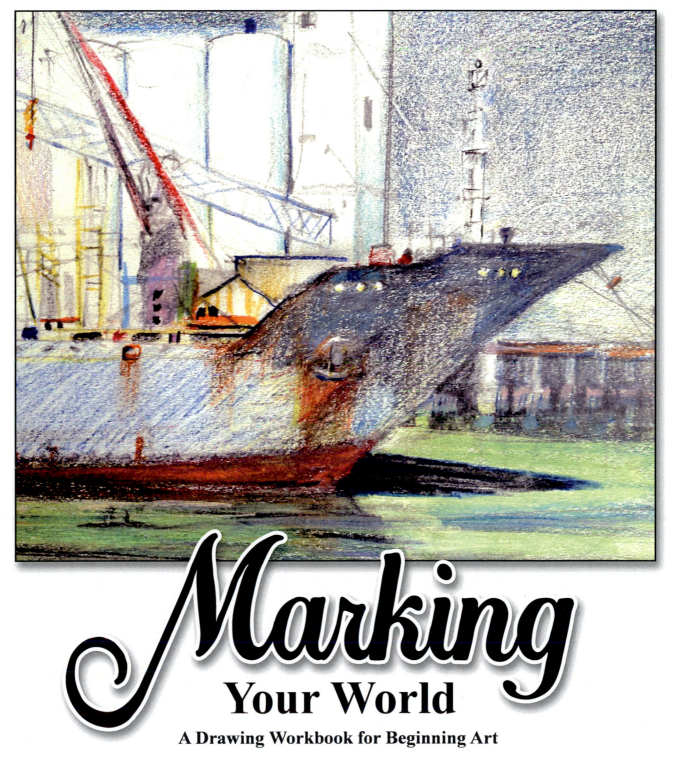

Marking
Your World
A Drawing Workbook for Beginning Art

With Instructional DVD

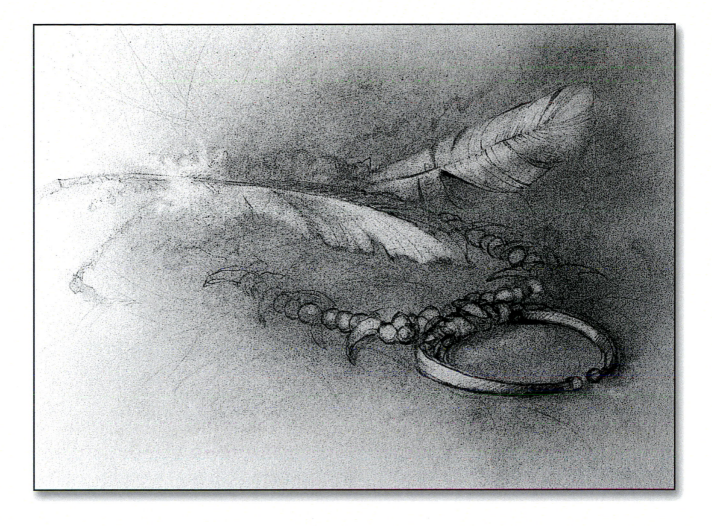

ISBN 978-0-9887003-0-7

Fifth Edition
Published by The Lamar Collection Printed by Urban Art Lithography

Table of Contents

Introduction

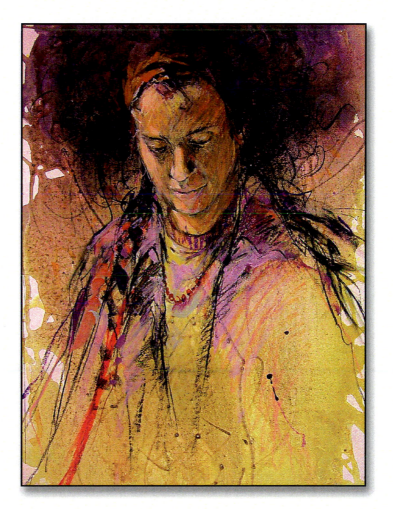

Acknowledgement

No project moves me toward success unless it is supported by the encouragement, direction, and wise counsel of friends, family, colleagues, and my awesome students. The combined efforts of all who contributed to this workbook challenged me and enabled me to reach my vision, especially in meeting the publisher's deadline. However, upon reflection, every aspect of the process was rewarding and inspiring. I am eternally grateful to all my advisors and supporters.

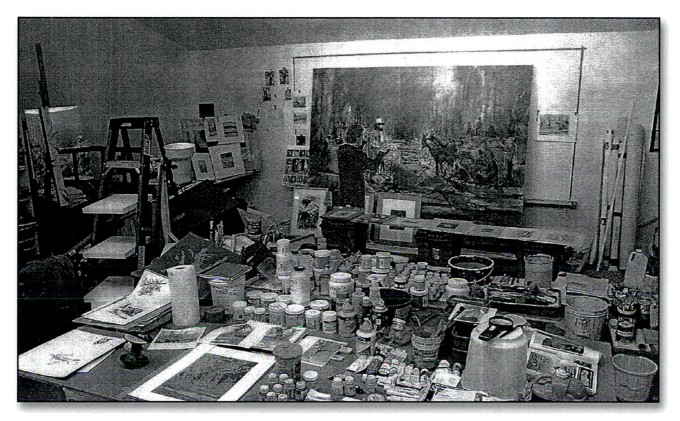

"Z" Studio

The people listed below had a vital part in the completion of the workbook:

Dr. David Bicker	Tamara Cochran	Bien Hoang..............	Aaron Stanley
Bob Bickley.............	Dr. Richard Dowdall	John Kloss	Thomas Starnes
Dr. Lehman Black ...	Henry Fisk	Dr. Jim Naify	Ken Stockwell
Meghan Blaising	Charles Hanks	Linda Shepard	Nicole Vismara
Samantha Boeger.....	Theresa Hanks	Scott Shepard...........	Alice Zamora..........

Carol Klippstein.. Graphic Designer
Bruce Lysongtseng Graphic Designer
Robert Saari ...Editor
Anne Powell ..Editor

... and the many students who volunteered their creative efforts.

A special dedication to:
My Granddaughter, Abigail Grace Cochran

A special thanks to:
My Wife, Marcia Zamora
Who kept nudging me towards the "finish line"

Welcome

Welcome to my class and to what I trust will be an exciting and life changing experience for you. It will be life changing in the sense of a new awareness of the world immediately around you. A world that so many of us for the most part, do not focus on, and a world quietly offering a multitude of beautiful forms hidden in shadow and light. Forms that are rich with colorful shapes of tone defined by line and texture. What I am offering you in this course will allow you that discovery.

Which brings me to the question, why take all this time to write a workbook on drawing? Well, I think it is about connections. Many of you have been introduced to me through friends and family who have taken my classes in previous years. It is many of these same students who have encouraged me to write my thoughts and to package the material in book form. The purpose, therefore, in this drawing workbook, is to present the same instruction and the pertinent material that in my teaching experience has proven to contribute to the success of hundreds of these former students.

The workbook is structured for the beginning student. It is intended for those with little experience, whether enrolled in the class or exploring the world of drawing independently. All you need is to want to draw and be curious about the basics. This workbook will be significantly informative and provide substantial assistance.

Success is not easily achieved in art making, especially if students consider themselves "just a beginner." I believe, however, that it is a goal that is attainable by anyone. There is no talented or gifted person that can disregard these foundations in the initial drawing process. Everyone can succeed with determination, effort and practice.

What you will confront in your initial journey, and what almost everyone experiences, is the fear of marking a blank piece of paper, fearing the drawing is not communicating what you intended. I want to encourage you to not give up but be consistent and focused as you pursue the art of drawing. I assure you that you can learn to draw your world, and that what you express about that world is valid. Just bring an attitude of openness, together with a willingness to make the commitment. With some practice and an understanding of the process of drawing, you will find what many of my students have found: that there is a fulfillment of oneself that is ongoing as you grow as an artist. You will get totally excited! This fulfillment will grow as you develop as an artist and begin to understand and appreciate the incredible works that have been conceived and expressed throughout the history of art.

The general overview of this drawing course will be the connecting or the linking of drawing media experiences with the creation of VISUAL ILLUSIONS. Two broad categories of art, Representational Art and Expressive Art will be studied. These will link to two media categories, dry and wet media, and the application of these approaches to various exciting drawing assignments.

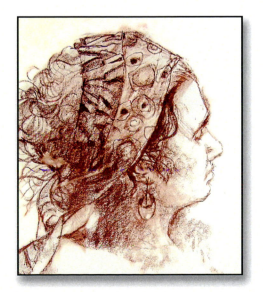

Students Speak

Thomas Starnes

Passion! A passion for making art, and a passion for teaching it. That is what Professor Zamora (affectionately known to his students as "Mr. Z.") brings to the classroom. I was a student in Mr. Z's classes at Sacramento City college in 1992. I had been drawing since childhood, but my artistic visions were shackled by my limited knowledge and experience. Now I was hungry for really good, solid art instruction (something that was in short supply in many college and university art departments at that time). Mr. Z emphasized fundamentals of design and composition through numerous practical "how-to" demonstrations of drawing and painting technique. His classroom demos and sketchbooks exhilarated and inspired me, opening my mind to the endless possibilities of visual art. After the first day in his pen and ink class, I ran out and bought a black, hardbound sketchbook (just like the ones he was using at that time) and feverishly filled page after page with sketches and notes of my own explorations of drawing.

After Sacramento City College, I continued my studies at San Francisco's Academy of Art, where I drew and painted for many hours every day, putting into practice everything I learned, deepening my knowledge and honing my skills as best I could. Upon graduation, my illustrations garnered a number of awards, and I was accepted into a training program at Walt Disney Feature Animation. Thus, began a career that has spanned nearly two decades (so far) working in various trenches of the animation industry, commercial illustration and art education.

Looking back now, I remember Mr. Z's classes with great warmth and fondness, and I reflect on the impact of his teachings on my life and career. In particular, I remember Mr. Z said that there are three areas which an aspiring artist should study: drawing, design, and art history. Drawing encompasses solid construction, proportion, perspective; all the technical aspects that go into making a sound drawing. Design encompasses aesthetic choices, and the understanding of what makes an image compelling. Finally, artists should engage with the art of the past, even as we explore new directions and attempt what has not yet been done. Art history provides context, a sense of where we have been, which can help us understand where we are going. An art career is bound to have many ups and downs (and mine has had plenty of both), it's a wild roller coaster ride which is not for the timid. But the opportunities that have come my way, and the successes I have enjoyed, all stem from my pursuit of those three areas to which Mr. Z directed me so many years ago. Perhaps even more importantly, and quite apart from the career aspects, there is the sheer joy and fulfillment of living a life in art, of creating something every day. For his teaching, encouragement, and support, I am forever indebted to Mr. Z.

Linda Shepard

"Before I took Mr. Z's class in drawing, my ideas of what drawing meant were conventional enough; that is, I would have defined drawing as rendering, in pen or pencil on paper, real or imagined objects in a naturalistic way. When I drew, I expected myself to produce a nearly photographic copy of the object, with exact details.

My drawings, as can be seen in my first attempts in my sketchbook for this class, were highly realistic and as meticulously detailed as I could make them. The painstaking care is obvious. The drawings are stiff and look isolated from their surroundings and from other objects like them. They stand alone, trying to look perfect. So even though they are realistic, they also look sadly unreal and boring.

Now, after this class in drawing, I am thinking and drawing in new ways. This has been a class in unlearning. Now drawing is not limited to realistic copying of nature; rather, it is not limited at all; it is a direct response to life, feelings, observations, and materials. Drawing now allows me to explore and to discover myself and the world. It allows me the luxury of making mistakes."

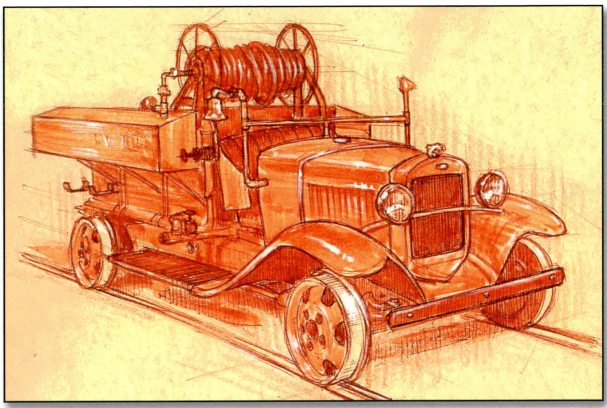

© Thomas Starnes

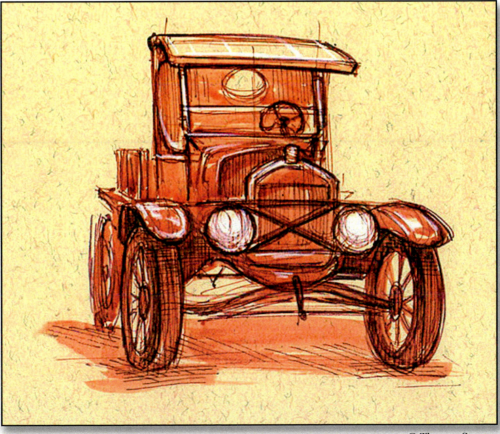

© Thomas Starnes

About Drawing

When you first pick up a pencil and put it on a surface, interesting things will happen. You begin an exciting journey into the world of art. It becomes your personal experience, pure and simple. As an art student, this new journey contrasts to when you were young, having fun doing effortless scribbles. Now you will engage in a more focused and intentioned purpose knowing that 'mark making' does communicate! With time, you will acquire a new awareness of seeing and experiencing the physical world and its structures that as a child you randomly scribbled. And, when you attempt to draw forms in the way that they appear to you, the efforts you observed by other artists will help you realize that drawing well is possible. As an instructor of many years, I know and am confident that you will draw what you see!

It has been clearly expressed in the many books on drawing, that there are prerequisites to consider before you learn to draw. These preliminary steps may be initially intimidating as they deal with visual language essentials, matters of the drawing process, vital concerns in graphic communication, and essential considerations of the drawn line. However, these aspects of drawing are paramount and essential for you to explore, understand, and utilize as you make the serious commitment to learn to draw with confidence.

Years ago, while having lunch with a fellow artist our discussion went from how artists perceive objects in space to the defining of the shape of objects in space. The conclusion, after several discussions, was that in drawing it is important to isolate and identify structure or forms that we draw. Having then a working definition of those structures, the process of drawing can be done with more facility and boldness; it is "DRAWING FROM WHAT YOU KNOW".

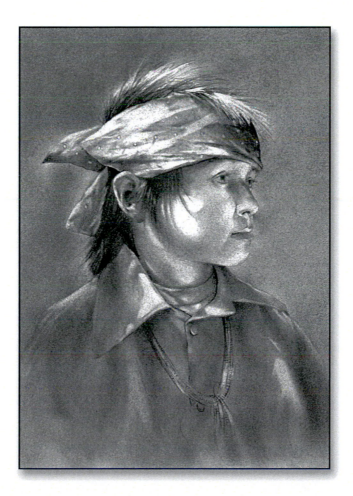

In this textbook you are going to be presented with acronyms and initialisms that define the factors that will guide you as a student of drawing. Learn about them, experience them, and understand how they give structure and enrich your life as an artist. Below are two acronyms and initialisms that will pave the way as you begin your study.

E.I.I.U.M.I.E.A.

Engage
As in any activity to ensure ultimate success an art student must be given to involvement at a high level.

Isolate
Drawing forms in a usually complex surrounding, involves the separation of subject or object from its surroundings.

Identify
Visually interpreting what we see can be done with greater facility if a student can categorize with some simple measure, the forms they observe.

Understand
Once the form connections have been made, an artist can now focus on rendering them.

Manipulate
After understanding what is observed, a student can proceed in altering or modifying the drawing to interpret what they see.

Integrate
The student can determine at this point what portions of the image satisfy the purpose of their intentions.

Evaluate
Having satisfied the drawing at this step, a student can reflect on the success of the drawing and is now ready to move to the final step.

Articulate
The final step is the communication by the student regarding the effort that transpired in creating the art piece.

P.A.L.M.S.

A general overview of the drawing activity is explained in the acronym of PALMS

Planes
When forms are observed in nature they are composed of planes, flat or curved, or the combination of both.

Artist
Each artist comes to the drawing experience with preset ideas, levels of experience, and awareness of art. Drawing exercises afford them opportunities to enhance their visual experience and improve the level of awareness, of forms and further their appreciation of those forms.

Light
An artist perceives forms revealed by the presence of light. Light allows the appearance of forms to emerge out of darkness.

Media
The drawing process or mark making is accomplished with the means of media, whether it be a pencil or a stick dipped in ink.

Structure
The observed form in the presence of light can be categorized into basic form structures.

Drawing Media in History

We begin by looking at some of the factors or influences that historically have impacted the changes that evolved in drawing. Advances in drawing have been marked by media to communicate the forms of subject matter and the corresponding symbolic language that represent the forms observed. This system of defining the illusion of space and advancing technologies also has been vital in communicating how those forms are to be best visually understood. However, it has to be understood that media or the material used in mark making is the most significant and the most vital element in the evolution of drawing.

Historically, efforts in mark making from primitive peoples developed with the use of natural minerals such as ochre, hematite, carbon, and manganese ground to a powder and applied to the damp stones in the caves of Altamira, Spain, and Lascaux, France. Archaeologists and scholars have determined that these pigments were applied with fur and feathers. Evidence has been found that suggests that some of the colors were blown by using hollow bones from large birds. The drawings of bison on ancient walls done with these minerals remain as a record of an activity of an ancient people.

These "first artists," by drawing these marks and symbols, expressed the first attempts toward successful communication. It could be that in these efforts they were defining the hunting experience or rituals of the hunt. Studies at the sites indicate evidence of scarring of the walls, marks that were apparently created by pointed implements. This may have reflected the practice of spears hurled at the drawn image of bison. It may have been a vital activity for the hunters practicing or preparing to hunt. This ritual or practice of "magic" assured them ultimately of food for sustenance, survival, and the continuation of a people. Viewing the drawings on the cave walls, we cannot help but consider that the one critical component in this work is the fact that these images are still there. With this in mind, the permanency of the media used to create the images becomes the essential and vital ingredient in the documentation of past cultures. Without this, they would have been lost. The study covered in this workbook will link to such historical activity of mark making and symbols by what we will observe and then successfully draw.

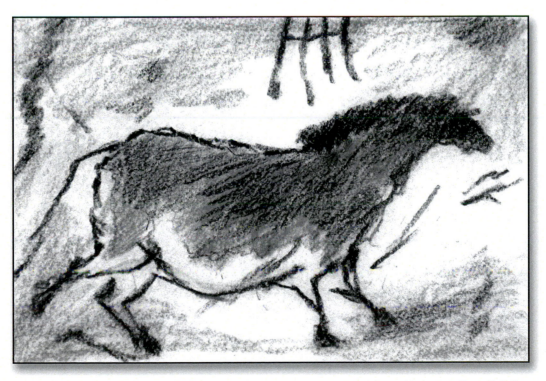

Interpretation of Lascaux, Cave Painting

Materials & Supplies

Below is a list of basic supplies for this workbook.

1x.........Art Supply Box or Container *(for storage of supplies)*
1x.........100 Page Sketchbook *(9 in. x 12 in.)*
1x.........Graphite Drawing Pencils *(2B, 4B, and 6B)*
1x.........Carpenter's Pencil *(2B or 4B)*
1x.........White Vinyl Eraser
1x.........Kneaded Eraser
1x.........A Set of Blending Stumps *(various sizes)*
1x.........Cotton Balls *(3 or more)*
1x.........Sheet of Neutral Gray Canson Paper *(18 in. x 24 in.)*
1x.........Sheet of Black Canson Paper *(18 in. x 24 in.)*
1x.........Set of 2, White Conté Crayon *(2B)*
1x.........Prismacolor Col-Erase Pencils *(rose, yellow, and blue)*
1x.........Set of 8, Crayola Crayons
1x.........Set of 8, Basic Soft Colored Pastels
1x.........Sharpie Pen *(fine point)*
1x.........Higgins Water Proof Black Ink *(1 oz.)*
1x.........Basic Watercolor Brush *(small size, round)*
1x.........#11 X-Acto Knife or Scissors
1x.........Sanding Block or a Piece of Sand Paper *(150 grit)*
1x.........Rubber Cement *(4 oz.)*
1x.........Basic Masking Tape *(1 in. x 60 yds.)*

About Sketching

If you were to ask any artist questions regarding "sketching" and the purpose of sketching in a sketchbook, the answer most assuredly will be that it is invaluable to the process of drawing. The practice of drawing often strengthens the visual experience in drawing what you see. It is experimenting, it is brainstorming for images, it is expressing ideas and shapes, it is the foundation for all artistic growth. So therefore, learning by sketching is foremost; it's all about understanding perception. It is observing and understanding the impact of all factors surrounding what we see. It is also a process of discovery from analytical and selective investigation. My recommendation for anyone is to practice your observation by attempting 5 – 10 sketches a week. During these exercises, focus on the different techniques and approaches suggested in the workbook. Do not get stuck in using just one approach to mark making. Remember frequent sketching is an invaluable experience for your artistic growth and becoming aware of your power to observe.

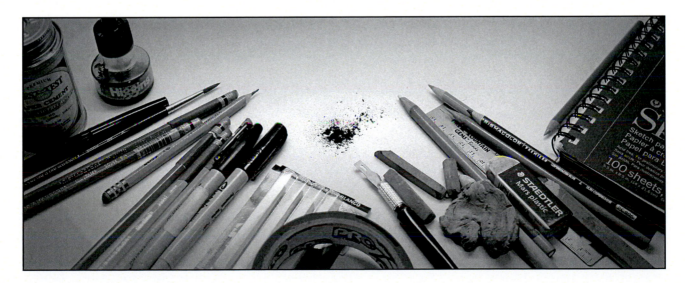

Art Terms

Abstract
Deviation from real form.

Concave
A recessed area or plane.

Convergence
Coming together, such as ray traces converging to a point in perspective.

Convex
An area or plane where a portion is pushed or extended outward.

Core Shadow
The darkest area of shade on a form.

Cross Contour
Shading around or across the form to show mass or volume.

Cross Hatch
Toning or texturing with short parallel strokes.

Draw Through
Drawing the hidden construction lines.

Five Basic Forms
Cube, sphere, cylinder, triangle, and rectangle.

Form Analysis
Understanding the composite parts that make up a complex object.

High Key
A composition where all the values are light.

Highlight
The lightest area on a form.

Light Logic
A natural application of highlight and shadow to the form.

Low Key
A composition where all the values are dark.

Major Axis
Refers to the greatest dimension of an ellipse.

Marking Your World
An effort to visually define your world by what you know and understand about drawing.

Media
The materials for drawing: pencils, ink, paint, etc.

Negative Space
The area surrounding the solid or positive objects.

Pattern
The logical repetition of anything.

Perspective
A 3-D illusion on a 2-D surface.

Picture Plane
Your drawing or painting surface.

Plane
A 2-D surface foreshortened as seen in space.

Stylize
Distortion with the intent to enhance.

Technique
"How it's done," i.e., realistic or abstract, tight or loose.

Texture
Surface quality: tactile or visual.

Three-Dimensional
Having form or depth.

Two-Dimensional
A flat surface, having no depth.

Uniform Tone
An evenly shaded area.

Value
The quality of light or dark.

Wash
A application of transparent tone using liquid media.

Whole Drawing
Seeing and drawing the entire composition.

Illusion of Depth

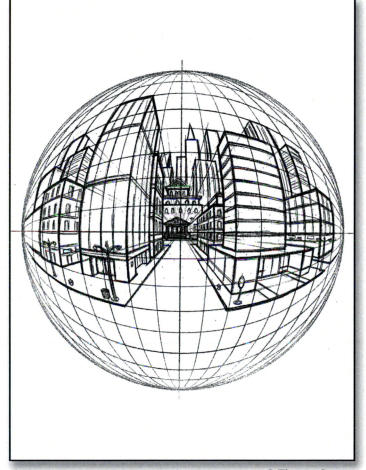

© Thomas Starnes

Perspective

Perspective is about the isolation and identification of the axis of the structure you observe and the character of the illusion of the planes of that structure. There are two kinds of planes for us to remember in identifying forms; they are flat and curved planes.

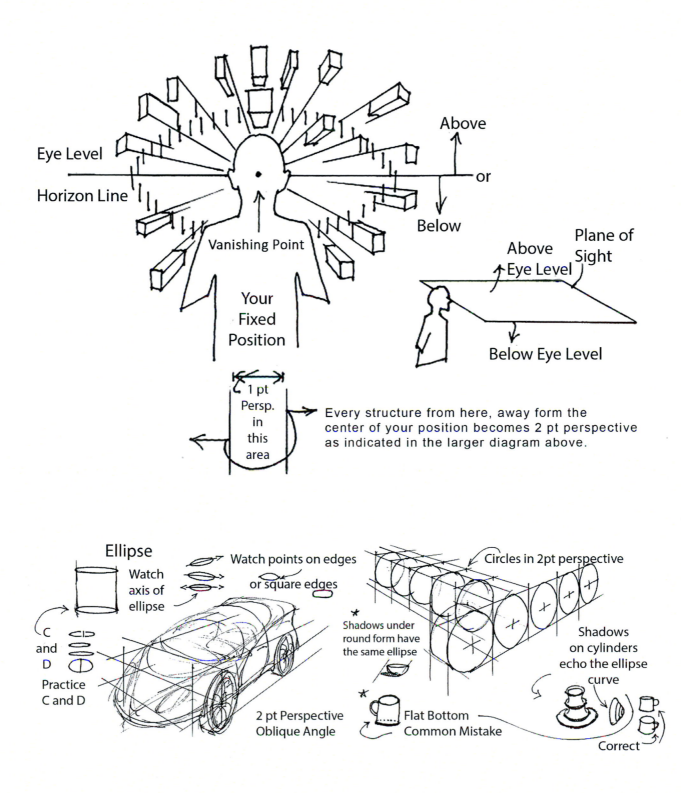

Eye Level

Horizon Line

Vanishing Point

Your Fixed Position

Above

or

Below

Above
↑Eye Level

Plane of Sight

Below Eye Level

1 pt Persp. in this area

Every structure from here, away form the center of your position becomes 2 pt perspective as indicated in the larger diagram above.

Ellipse

Watch axis of ellipse

C and D

Practice C and D

Watch points on edges or square edges

2 pt Perspective Oblique Angle

★ Shadows under round form have the same ellipse

★ Flat Bottom Common Mistake

Circles in 2pt perspective

Shadows on cylinders echo the ellipse curve

Correct

Next in importance is the vanishing point. It is placed at the center of the imagined or actual end of the eye level plane, see the diagrams on pages 15, 18, 19, and 20. For example, the actual end is clearly seen across the distant horizon of a large body of water.

In one-point perspective, it is to this point that the planes of forms converge, like a railroad track; this refers to side planes on either side of a viewer, as well as the planes above and below the horizon line. The size of the plane gets smaller as it goes away from the viewer, because it is farther away. In my years of teaching, there has never been a more important idea to understand, or more difficult to teach. That is why it is so important to practice working and applying the idea of one point on the horizon when doing any form of drawing. But, is there an easier or more tangible way to understand this? Yes, there is a way! The way is the clockface and the "Y" and "V" references.

Let me explain these two approaches. In both approaches we are talking about angles. If you mark your paper with a diagonal line from left to right, the end of the line may represent the center of the clock face. The other end will be the pointer and it is pointing at 2 o'clock. Anyone can draw a 10 o'clock line, or a 7 o'clock line. Try it.

The other approach refers to looking at either the top corner or base of a box or square structure that is at an angle to us. We assume that all vertical lines are straight and are parallel to all other vertical lines. Think about the vertical lines as in a man-made structure like in a house. All the vertical lines are straight and erect, the windows, doors, and the edges of the house. So, the issue is to read the angle or position of the diagonal lines that are connected to the vertical lines. The V is at the bottom corner of the box and the Y we refer to is at the top of the box. The next step is to determine the angles of the top of the box or the base of the box relative to the hour on the clock face. Refer to the drawings given.

The whole discussion on perspective can get very complex if we toss in the idea of multiple vanishing points. A student should begin with very simple drawings and stay with the practice of drawing one or two-point perspective studies. Study examples of drawings by going online and researching images done by architects, industrial designers, and artists.

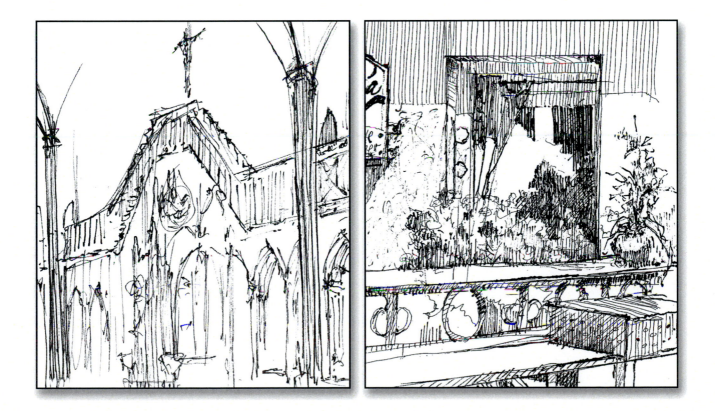

Axis and "Y" and "V" Reference

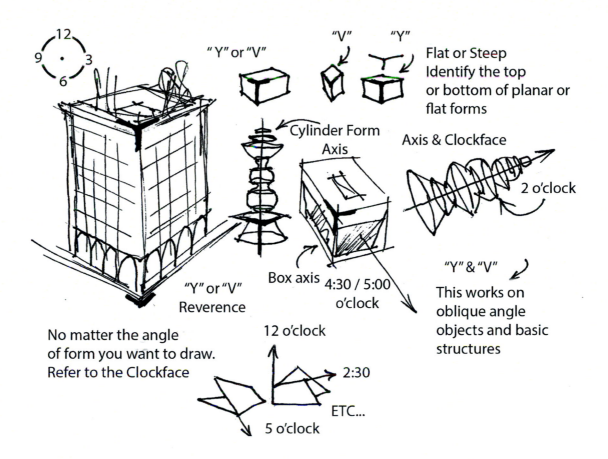

"Y" or "V"

"V" "Y"

Flat or Steep
Identify the top
or bottom of planar or
flat forms

Cylinder Form
Axis

Axis & Clockface

2 o'clock

"Y" or "V"
Reverence

Box axis 4:30 / 5:00
o'clock

"Y" & "V"

This works on
oblique angle
objects and basic
structures

No matter the angle
of form you want to draw.
Refer to the Clockface

12 o'clock

2:30

ETC...

5 o'clock

Even in the complex structures in the sketches below, you can determine the correct perspective angle of those structures.

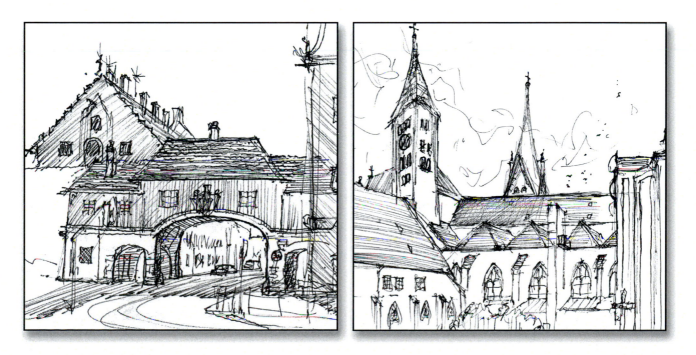

Clock Face Reference

One-Point Perspective of a Hallway

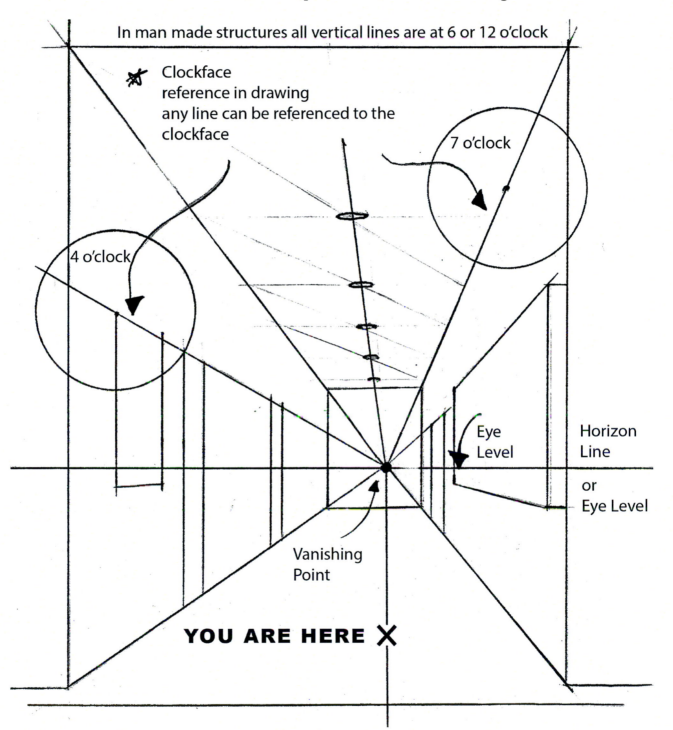

In man made structures all vertical lines are at 6 or 12 o'clock

Clockface
reference in drawing
any line can be referenced to the
clockface

7 o'clock

4 o'clock

Eye
Level

Horizon
Line

or
Eye Level

Vanishing
Point

YOU ARE HERE X

Clock Face Reference

Two-Point Perspective of a Hallway

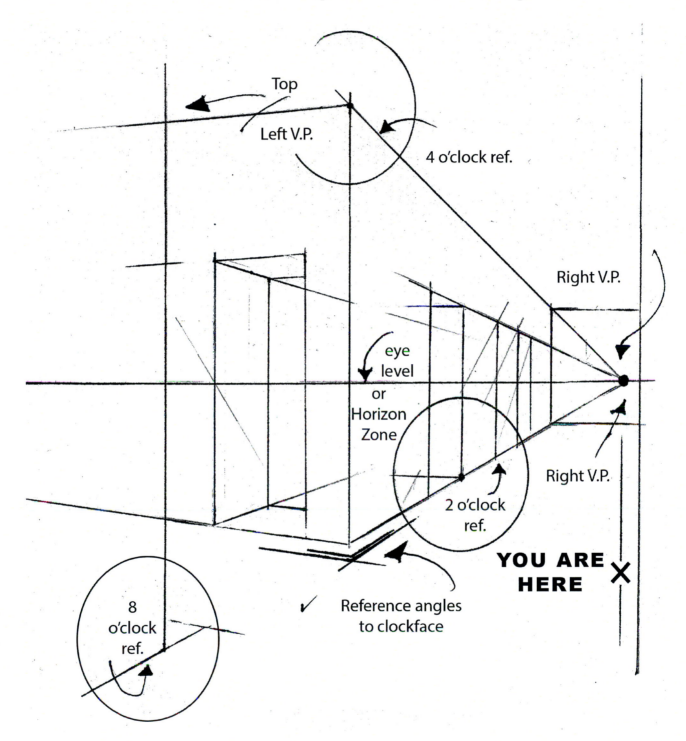

One-Point and Two-Point Perspective

Below is an example of one-point and two-point perspective with different shapes and forms that are above and below the horizon line or eye level. For a different view simply rotate this page to the right and see what happens.

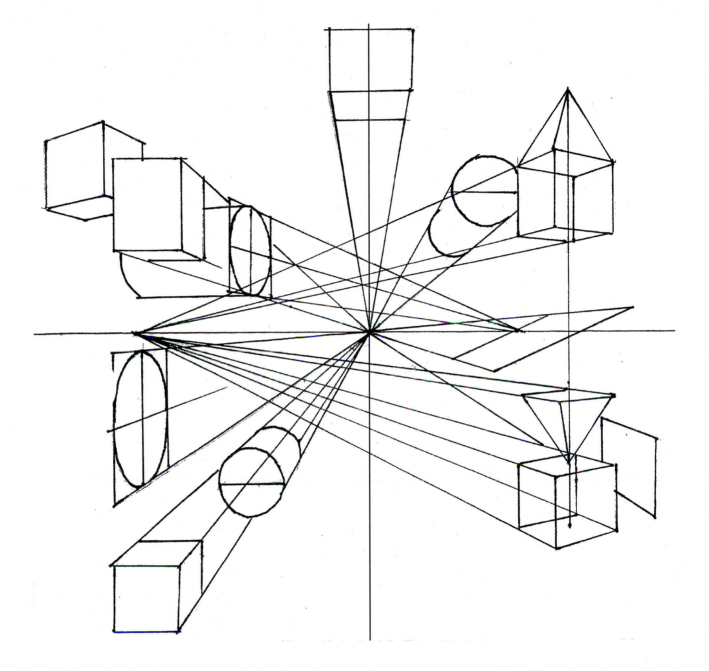

Examples of Two-Point Perspective

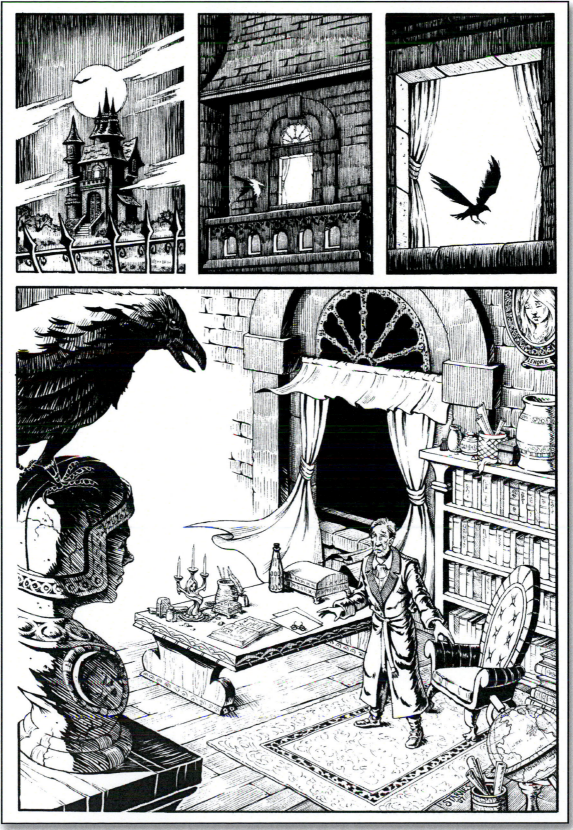

© Thomas Starnes

Creating Depth in Space

Space Illusion

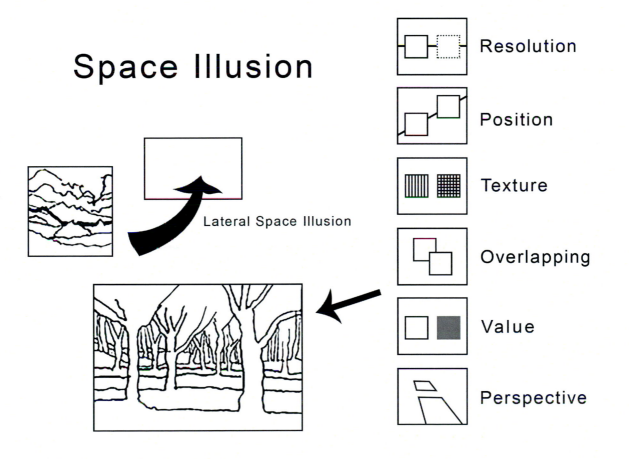

Lateral Space Illusion

Resolution

Position

Texture

Overlapping

Value

Perspective

The Elements and Principles of Art

The "What", the "How", and the "Where" of Art

The drawing process of which this book represents in it's modest content, is best understood to a be a language, specifically, a visual language. It requires a different mindset based on the factors of that language. These factors are the what, the how, and the where of drawing. They are implied or expressed in the flow of expression, and when these factors are explored with understanding by a student, a level of personal "controlled freedom" of expression is realized and attained.

Elements of Art

What we put together

Line The track of continuous dot.

Shape Defined area in 2D space // Form = Defined area in 3D space.

Texture................. Surface character.

Value.................... Light or dark quality of an area.

Color.................... Hue, intensity, value, and temperature.

Principles of Art

How we put elements together

Balance................ Symmetrical = equal balance // Assmetrical = "felt" balance.

Contrast Variation and visual interest variety.

Rhythm................ Pusle or movement; repetition of elements.

Emphasis Accent: center of interest, focal point; sub ordinance/dominance of element.

Repetition The echoing of similar character of elements to achieve a sense of unity.

Proportion............ Comparison of elements in terms of size, quantity, or degree of emphasis.

Project Area

The space in which an artist creates

Project Area The stage of visual activity.

Section I: Line

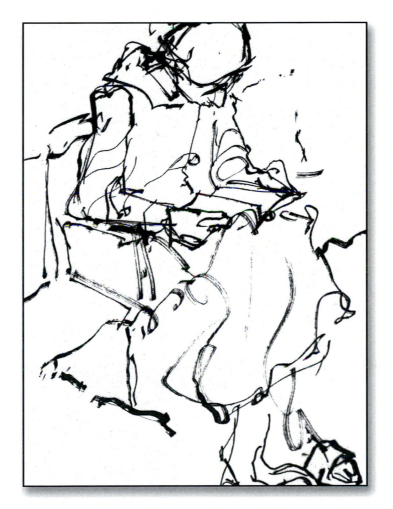

The Language of Line

Robert Beverly Hale, the highly gifted and articulate professor who taught at the Art Students League for over three decades, has given us a most accurate and concise yet comprehensive explanation of line.

"Line travels on imagined form."

Contour Line

When we draw, we can mark the surface of a drawing paper with scribbling lines that in our thinking represent a form. We in fact define that form by its outer delineation or the outline of the edges of the form. Simply stated, we draw a tennis ball by a line that completes itself in the fashion of a circle. We see that the line does "travel" on the outer limit of the structure. This simple line explains graphically what we understand to be a contour line. It is also generally accepted that a contour line appears with little variation in thickness; it is consistent in its thickness; and it appears as a mechanically drawn line on a surface.

An exercise that assists students in the drawing process is to use such a line to train the eye and the hand to "see" form and visually communicate form.

This exercise has to do with focus. It requires that the student concentrate attention on the object and look at the drawing surface only after the completion of a small section of the form before continuing. Or the exercise may require that the student not refer to the drawing at all. Some folks call this, interestingly enough, "blind contour." This exercise will often yield structurally unusual drawings, and that is all right. What is important is the process of eye and hand coordination and not the product. This type of drawing is best done with a ball point pen or a fine felt tipped marker.

Another method in this approach is to generate a drawing by not lifting the pen off the paper, a sort of "continuous meandering line" approach. It may appear to be just scribbles or massing of marks, but as you work, the idea of understanding the shape structure of forms will be reinforced. Try it.

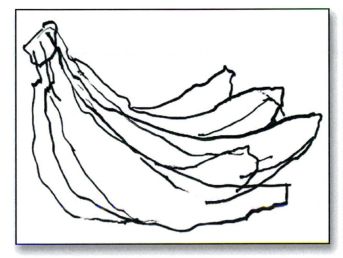
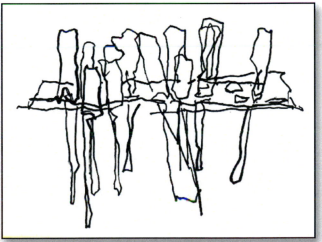

Gesture Line

Gesture line has variation or change of thickness, in contrast to contour line. These lines are expressive and exciting. They are also autobiographical and immediate. They command our attention. In drawing practice this line is usually utilized in Portrait or Figure drawing classes where the mediums of pastel, Conté or compressed charcoal sticks are used. Drawings using such lines are drawn with a wider drawing tool or brush and are usually done in a short amount of time. So, in contrasting the two lines, we become aware of the distinct difference; the contour line is mechanical and predictable and safe; and the gesture line is the complete opposite. We can compare this difference to the first efforts of writing an alphabet. As a child, every mark to define the character of letter forms was carefully and methodically done. Today our writing, especially of our signature, is spontaneous and full of energy. We will experience this approach to lines in our study of ink.

Refer to the drawings given and go online and research artists who work exclusively with contour or gesture lines.

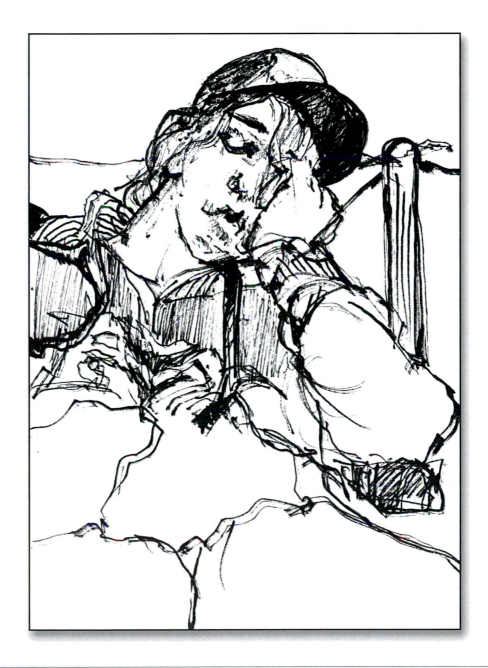

Cross Contour Line Reference

Curved Line Character on Round & Cylindrical Forms
Example: Human masses, trees, & organic forms

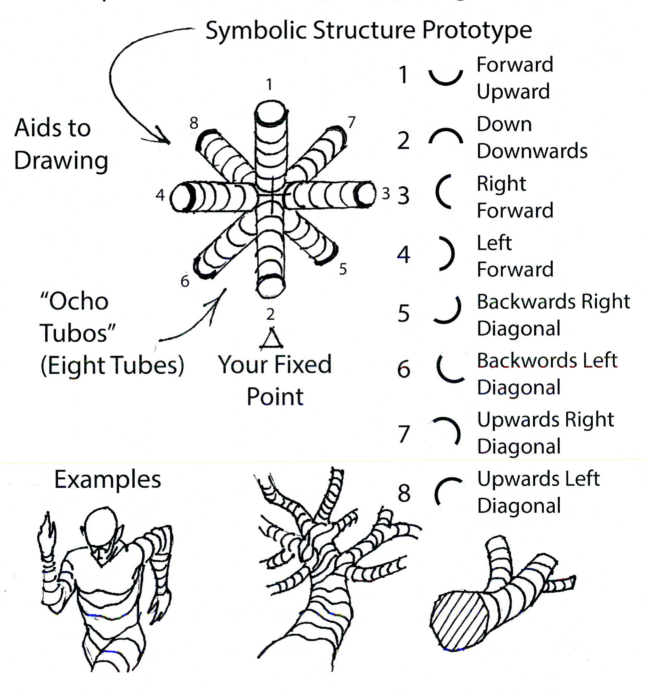

Symbolic Structure Prototype

Aids to Drawing

"Ocho Tubos" (Eight Tubes)

Your Fixed Point

1 ⌣ Forward Upward

2 ⌢ Down Downwards

3 (Right Forward

4) Left Forward

5 ⌣ Backwards Right Diagonal

6 (Backwords Left Diagonal

7 ⌢ Upwards Right Diagonal

8 (Upwards Left Diagonal

Examples

Examples of Line Drawing & Line Variation

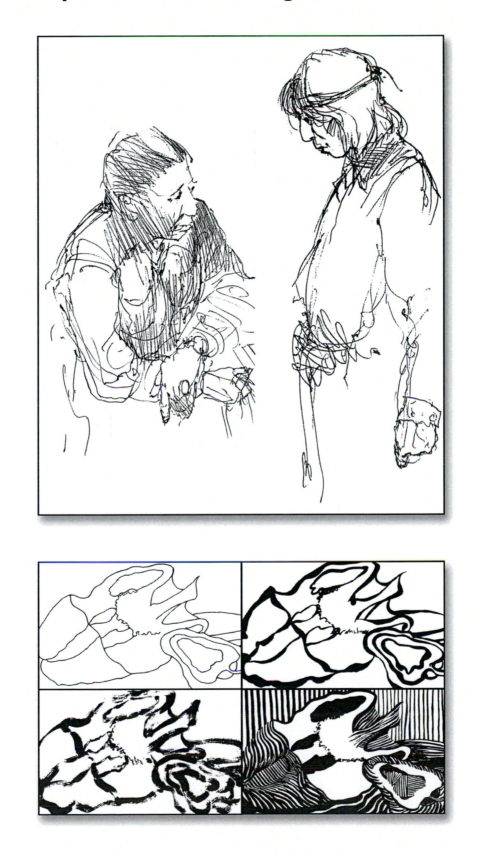

Section II: Shape

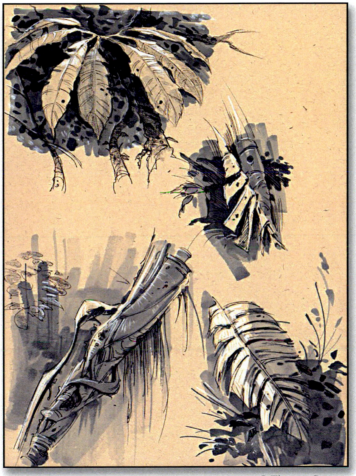

© Thomas Starnes

Shape and Form Categories

Before we itemize the identity of forms we need to consider some thoughts about limitations. Beginning students are encouraged to consider answers to these questions in drawing:

- What do you understand to be your ability of working with the marking instruments that you choose to draw with?
- How sensitive are you to the surface on which you draw?
- Do you understand who you are relative to drawing; that is, what are your limitations in the drawing process, the level of ability, boldness to chase a challenge, and courage overcome any fear you bring to the experience?
- Are you able to define or categorize the shape/s of your subject or objects that you are attempting to draw?

The first three questions allude to individual choices and your personal working resources. These questions will be resolved during the course of your study and your attention to respond to them will determine the level of your successes.

Let us focus on the last limitation, the category of the shapes of objects. You can't draw an object without first having an awareness of volume you have to think and see "round." Remember, in drawing we are creating an illusion or the appearance of an object on a flat piece of paper. This is a big challenge that can be made easier by the focus on the sense of roundness.

You will notice the chart on the next page that there is a reference to 2-dimensional shapes and 3-dimensional forms. The idea of volume is the 3-dimensional part of this, the round orange with highlights and shadows. The 2-dimensional part is the flat looking drawing of just the outline of the circle without modeling, like a contour drawing that we discussed before. Notice that the contour drawings of a triangle or cone, a box, or a circle are all flat looking. This illusion of flatness we call SHAPE, and the illusion of roundness we call FORM. When we start the process of drawing we must first think of "the shape or outline envelope" that contains the form. This may be referred to as symbol shape.

Next, to draw the objects we have to think of the influence of light on those forms. In considering the light influence we notice light and dark contrasting values on the subject matter. When those values are in the right place, highlights, halftone, etc., the drawing appears convincing and solid looking - a "drawing with roundness."

What follows now are the categories of the forms. There are four categories of forms listed on the next page with a cue word that helps identify them. These will help establish our judgment of the structure of objects.

Diagram of Shape and Form Categories

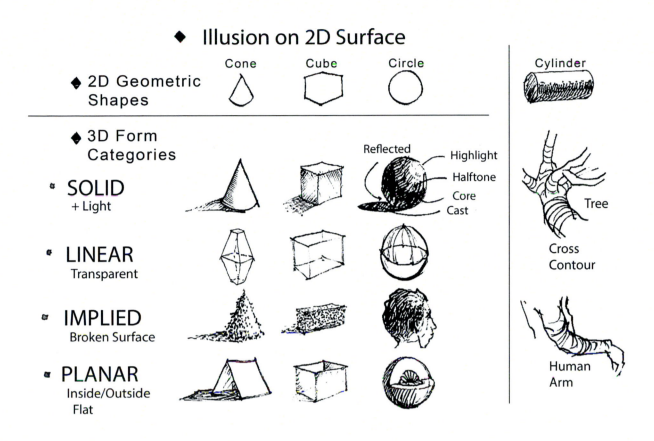

S.L.I.P.

Structures can be categorized into basic shapes and forms. That are either two dimensional or three dimensional. Shapes are two dimensional forms and forms are three dimensional shapes.

Solid
There are forms in nature that do not have a volume. They are flat shapes. Forms appear where light exist to bring the appearance of the light, gray, and dark planes of the structure.

Linear
Objects that are transparent fit the category of linear. They are drawn using line to define the front and back of the form. An example would be a cube of ice or a square of jello.

Implied
Some structures are not solid or linear, but their surface planes are broken. An example would be a sponge, a hedge, or a head of hair.

Planar
Structures are identified by the fact that the outside and the inside of the form is observed at the same time.

When we add a light reference and value to any flat geometric shapes, we create an illusion of a Solid or compact form. Solid forms like round fruit, door knobs and baseballs must be drawn in this manner. The next category, Implied forms, are understood to be any form with a broken surface. The S.L.I.P. chart that appears on the previous page suggests implied forms in a drawing: a drawing of a pine tree could be in the shape of cone, a rectangular shape could imply a sponge, and the hair on a person's head could be an implied sphere. The objects that are in the Planar category reveal an inside and outside from any view. Examples of these categories are illustrated on the S.L.I.P. chart: tent for a triangle, an open box for a cube, and cut up fruit for a sphere. Glass spheres, fish tanks, and triangular post lamps represent the final category of Linear or transparent forms. To effectively draw linear forms, we must think of the idea in drawing called "drawing through." That is, seeing and drawing what is on the other side of forms. An empty fish tank has to be drawn by including the receding lines and the back edges of the bottom of the tank

In studying these categories, a student should realize that in nature, not all real objects are this pure. They are, more often than not, combinations of these categories and are sometimes very complex. A good example of complexity would be a food blender that is part glass, flat, with a chrome, metal body, round knobbed lid, and a textured hard rubber handle.

Below is an illustration of using flat shaped elements to create dynamic compositions.

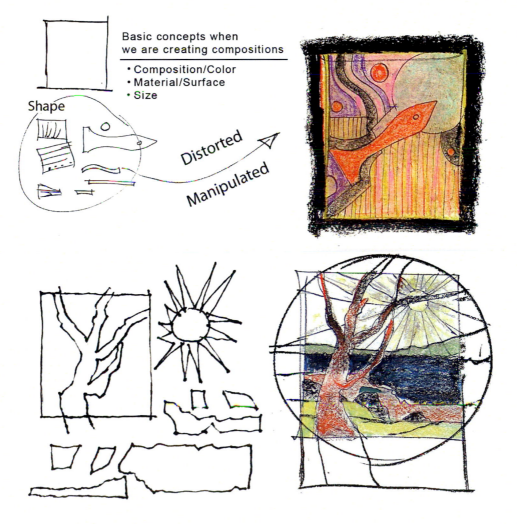

In working from nature, don't just look at the object, look at the SHAPE of the object, and the shapes within the shapes of the overall form.

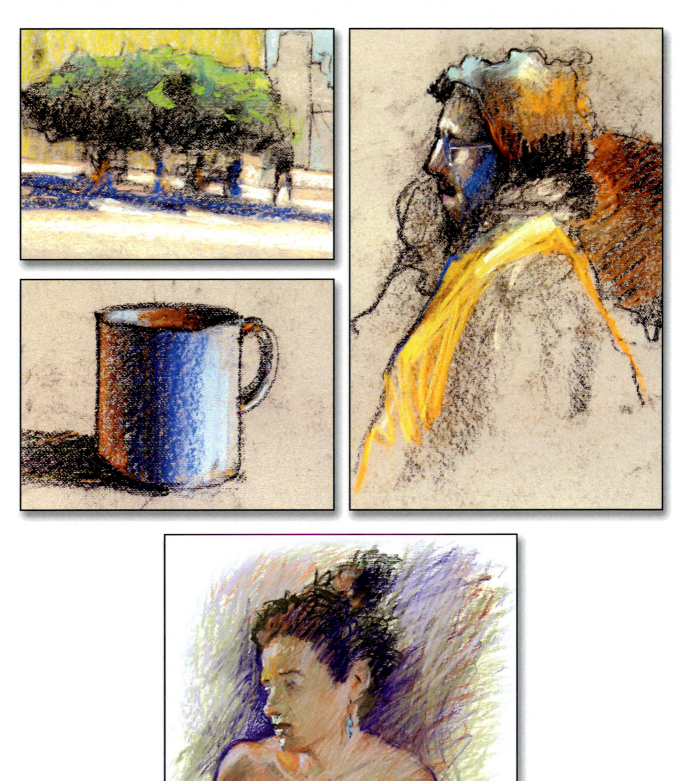

Form Illusion

Thinking visually from a flat 2D shape to a real 3D form.

1. Flat Shape
2. Basic Form
3. Real Form

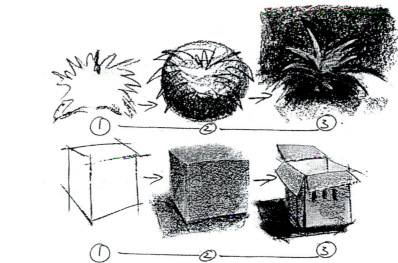

**Several methods to assist you in the drawing
of forms and the proportions
(size relation of parts) of shapes in space.**

Alignment	Mapping	Unit of Measurement	Major & Minor Axis of Forms
Visually implied line of shape, parts, or edges.	Reference with dot or mark, etc.	A specified unit of the object that can be used to check relative proportion/ size of observed forms in space.	

Au.Su.M. *(Assume)*

Axis
The axis or the angle of the directional force of the form in space. Students are to consider the linking of this angle to the "clock face" reference idea.

Shape
The apparent silhouette or structural 'symbol shape' of a form in space. This is a two-dimensional focus as opposed to a three dimensional "volume" reference.

Mass
Adding light to a form defines the value segments or planes of that form in space. And adding the correct value/color contrast to the planes results in the appearance of a three-dimensional illusion of form.

Light

W.L.W.S.C.A.V.A.S.C.A.V.W.U.F.

With Light We See Color And Value And Seeing Color And Value We Understand Form

Of great importance in observing subject matter is the influence of light. Let's look at how the light in any room will influence what appears before us and consider this in terms of black and white. This is accomplished by our understanding and practiced perception of the levels of illumination.

There are three levels of illumination around us. Dominant light: the strongest source present in the drawing process is dominant light. For example, during the day the light from the sun coming through a window illuminates all that we see. A secondary source would be the incandescent lights in the studio; they are the generalized or ambient light. A final determining influence, and the one that is most critical in the subtle depiction of nuances of form, is reflected light, because light travels in a straight line and does not bend around objects. Therefore, reflected light bounces off of any light surface, like a wall, the white cabinets, a pale value or colored object, next to a form, and most certainly, the white surface underneath the object. This light reflection illuminates the shadow side of the object you are drawing.

Form Surface and Light

A plane is the "Skin" of a mass. Consider the shape of the mass on forms and the light striking and reflecting off the surface.

These planes are identified by more specific terms:

1. HIGHLIGHT
Planes most nearly in direct angle of the light source.

2. HALFTONE
Any plane at an angle to a light source.

3. CORE SHADOW
A part of a curved form not reached by light or a part of the planar form where a plane change occurs.

4. REFLECTED LIGHT
Light that is bounced back into planes in a shadow area.

5. CAST SHADOW
When an object intercepts light and casts a shadow on another plane.

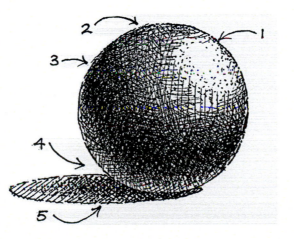

The level of illumination on the sphere on the previous page illustrates the role of the dominant source of light. Notice that as the curving planes go away from the light source, each illustrated segment changes in value and can be assigned a specific number. The lightest light is called highlight. It becomes number 1, the half tone is number 2, the third number will represent the darkest part of the form, which is called the core shadow. The core is any plane that lines up with the angle of the dominant light and therefore no light can be reflected from it. Reflected light is number 4 and is the light that is usually bounced from an adjacent plane. Notice that the cast shadow that is number 5 changes in darkness from 5 to 4 as it is drawn away from the sphere. Also, notice that the axis or direction of the shadow shape follows the angle of the dominant light source.

A.I.C.C.

The various characteristics of light can help us understand how illumination explains form.

Angle
The impact of angle or direction of light affects the internal shadows in the form and the cast shadows away form the form.

Intensity
The brilliance of the light impacts the perceived clarity of forms, in terms of value contrast and color. The brighter the light the clearer the perception.

Closeness
The characteristics of forms is more obvious when the form is near to the light source.

Character
The surface appearance of form, whether rough, smooth, or reflective are revealed by light.

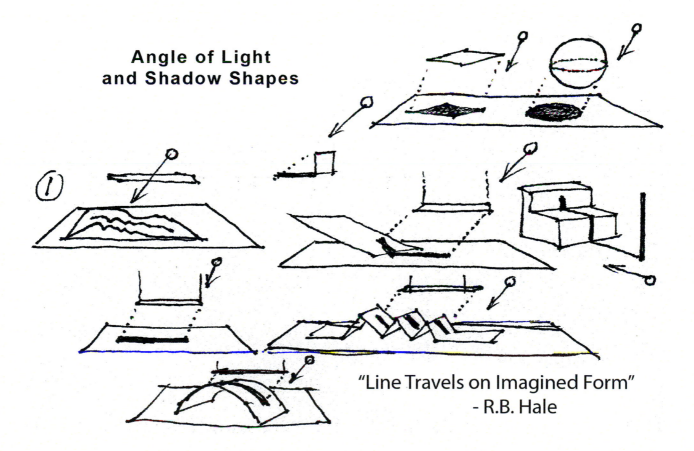

Angle of Light and Shadow Shapes

"Line Travels on Imagined Form"
- R.B. Hale

Angle of Light and Cast Shadows

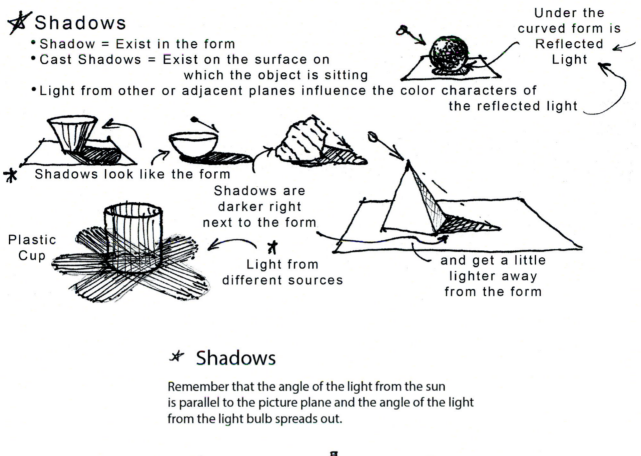

✗ **Shadows**
- Shadow = Exist in the form
- Cast Shadows = Exist on the surface on which the object is sitting
- Light from other or adjacent planes influence the color characters of the reflected light

Under the curved form is Reflected Light

Shadows look like the form

Shadows are darker right next to the form

Light from different sources

Plastic Cup

and get a little lighter away from the form

✗ Shadows

Remember that the angle of the light from the sun is parallel to the picture plane and the angle of the light from the light bulb spreads out.

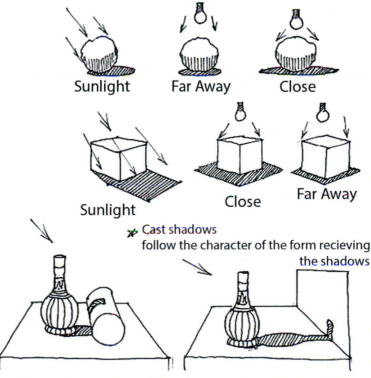

Sunlight Far Away Close

Sunlight

Close Far Away

Cast shadows follow the character of the form recieving the shadows

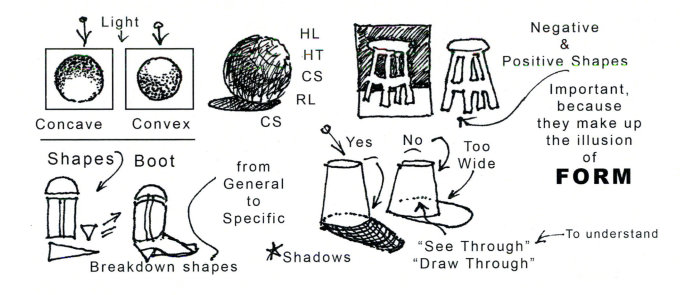

A student must practice observing simple forms under different lighting conditions to understand how this actually works. It is recommended that students practice drawings of forms like eggs or an apple, illuminated by a bright lamp or a flash light. The purpose in this exercise is to study how the light impacts the form. It is obvious that the dominant light source greatly affects the appearance of those forms. The theory behind this way of working is that convincing illusion making begins with attention to these first steps. And from here, we observe that success in creative work can be based on a good foundation of understanding the visual language accompanied with frequent practice.

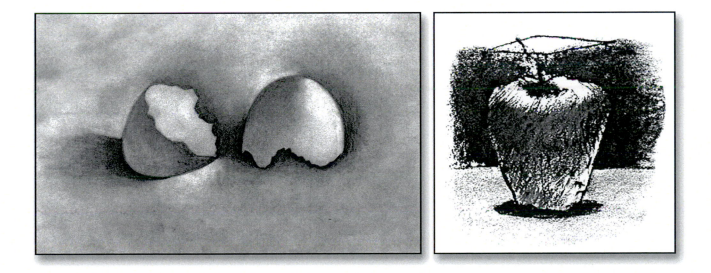

Section III: Value

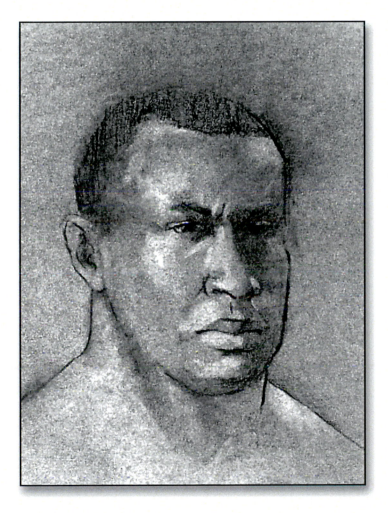

The Language of Value

First, we must define the word value. Value is simply the contrast of light and dark. We must then consider where this definition fits into our large picture of art. To clarify this point, we must know that value is part of the language of color - we will address color and the logic of color use later on in the semester. So where does value fit? It fits within the definition of color. Color can be identified as having three properties: hue, intensity and value. Value is the contrasting quality of any color. Therefore, when we observe a dark color like deep purple, and we are doing a black and white drawing, we can identify it as a dark value in our drawing.

Defining and understanding the language of value involves also the clarification of the components that make up the condition of contrast. If we observe the process of the marking of a paper surface with pencil, we notice the components of contrast and become sensitive to the varying lightness or darkness of the marks. The pressure we exerted on the paper resulted in a contrasting line - the more pressure we used, the greater darkness of line; and conversely, less pressure resulted in a light line. When we work in the area of tone or shading, darker values are created by a greater density of graphite particles or color applied to a surface. When less graphite or color is applied, the white of the paper combines with the reduced medium to give the illusion of a light value or tone.

Another factor that must be understood in studying value is the idea of scale. A student doing, for example, a drawing of real forms, must observe the portion of the form they are wanting to draw. If a scale of values is understood and referred to for comparison, then the proper value will be used to define that form. We can refer to such a scale having five segments represented by the numbers 1-5. We referred to this scale earlier when we discussed light. The number one (1) will equate to the lightest value, and five (5) will represent the darkest value. Doing an exercise with this approach in mind will give a student valuable experience in comparing values, so when the actual drawing process occurs, a student can base their decisions about value on what they understand about the scale reference. The time spent in comparing the parts of the form to be drawn or painted to a scale sequence will assist a student's ability to make a more correct judgment.

Transitions and Sequences of Values Pt. 1

The following information is closely related to page 71 - Ink Application: Transitions and Sequences of Value

As stated before, when we approach the subject of value, we open the door to the exploration of the concept of light and dark contrasts of forms. We notice the light and dark transitions of value or scales for example, if we place an envelope in front of us and fold it in half, we notice that the surface on top is lighter than the darker value that is folded underneath. Upon careful scrutiny, it is clear that there are transitions of value on those surfaces that appear to subtly become lighter or grayer.

What method can be used to draw contrasting values - light and dark? There is a method to accomplish this and to draw the envelope successfully.

We approach this task by first understanding the transitions or sequences of value change. Consider the "sound" in music. As you know, there are different sounds and changes of tone in music. These are understood by qualifying or quantifying these changes of sound. This is accomplished by notes on a scale. In drawing, it is the same. We can break these transitions on the envelope into identifiable scales, both light and dark. In our first exercise, we will do this. We will develop a scale of reference to gain an understanding of how this illusion can be accomplished.

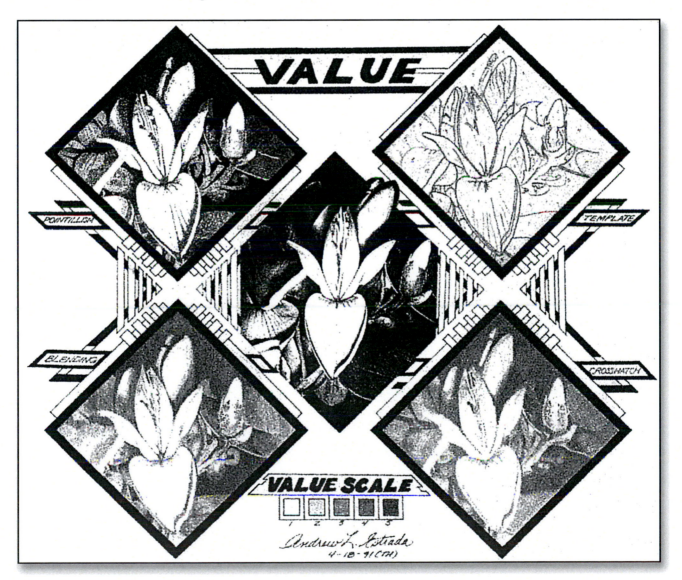

Value Scales

The lesson in this project will enable you to:

- Define the function of light.
- Understand that value shapes can be isolated and identified.
- Control values in depicting form.

In this exercise, you will first work in a dry media, using pencil. You will need a carpenter's pencil, Xacto knife, cotton balls, a ruler and drawing paper. The procedure requires that you make some graphite powder by scraping the chisel point of a 2b or 4b carpenter's pencil with the Xacto knife. The result of this scraping is the powder for the project. Secondly, you will then apply the powder with a cotton ball to the drawing paper with an irregular motion to avoid any "donut hole" tones or diagonal marks. Touch the cotton ball gently to the paper surface. The objective is to make enough 2" squares of tones from light to dark to select five squares. Refer to the examples given. You will have to create extra squares because the selection is easier with many choices. Remember, a light touch will be necessary for the lighter tone values and more application of dust is needed for the darker tone values. The scales should represent the percentages of 1=5%, 2=25%, 3=50%, 4=75% and 5=95% of black tone. This will become your scale. There is no perfect scale for our exercise.
Some student's work will represent a slight shift toward dark and other student's work may shift toward a lighter scale. Don't let that bother you. Remember this is your scale.

The task is made simple by starting the project with the lightest value and then mixing to the darkest value. It is a project to develop your judgment of value, changing from one square to the other. The process will teach you the possibility of isolating and identifying areas of value contrast. Once you have determined the sequence and selected the squares from 1 through 5, you will cut them into sizes of 1" or 1 ½".
Next you will mount the squares ¼" apart by gluing them with rubber cement. Refer to the samples given. This is the first part of the project.

The second part of the project will shift to a wet media approach to create a scale. Using a pilot ink pen, you are asked to match the range of values you created in pencil. Since ink is obviously darker than pencil, you must allow some white of the paper to show through the marks you make to visually blend with the black marks and create a matching gray. You must do this for the entire scale. The kinds of marks that you may use are hatching, cross-hatching, dots, or meandering scribbles. The only concern is that you match the ink squares as close as possible in value to the pencil squares. Finally, you are to cut and mount the squares like the pencil ones. Both of these exercises are to be mounted on the 18"x 24" drawing paper as demonstrated in class. Refer to the samples given.

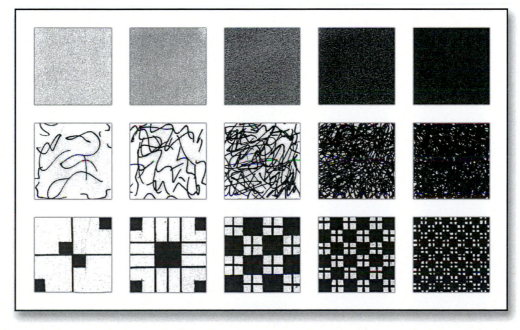

Photo Piece

The lesson in this project will enable you to:

- Select and identify specific values related to a value scale.
- Understand shape as a two-dimensional form.
- Experience the recreation of consistent value shapes with texture.
- Develop a sensitivity to creating texture by the use of dry or wet media applications.

With this project, we continue to focus on value and reinforce your power to select and assess value contrast in shapes. The procedure requires that you find a photograph that contains a variety of contrasting SHAPES that are light in value, medium in value and dark in value. This image may be something that you photographed or it may be taken from a magazine. Select a section approximately 4"x 4" in size. You will then take a piece of tracing paper and trace the image. Next you will make a carbon sheet to transfer the image. If you already have a carbon sheet, you may use it.

To create a carbon sheet, you will take a piece of tracing paper and completely cover the back of the sheet with many marks from a 4b or a 6b carpenter's pencil. Once this is done, take a cotton ball and in a circular fashion, rub off the excess graphite.

You will follow this by tracing the shapes in the photograph. This will look like a contour line drawing of shapes. After this is accomplished, indicate the identity of each shape with 1, 2, 3, 4, and 5. This links to your first assignment of the range of scales we are studying. Refer to the illustrations given. You will notice that in some photographs, some of the shapes could be broken up into divisions between the steps in the scales, like 1.5 or 2.7 etc. Don't concern yourself with that for now. At this point stick to the predetermined categories of 1 through 5. If a shape of the subject is dark, it will be a 5 and conversely, if a shape is light, mark it with a numeral 1.

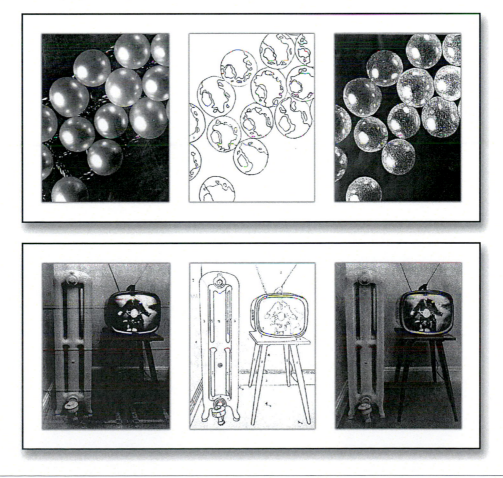

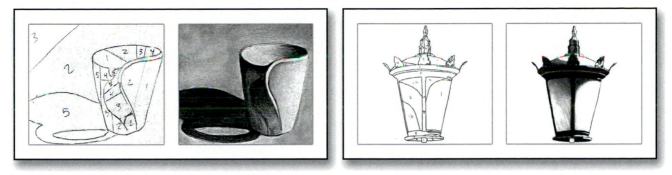

Transfer the image to your drawing paper. As you look down at your drawing surface, transferring will be accomplished by first positioning your drawing paper on the desk. On top of this paper you will place the carbon paper face down. Then you will position the tracing paper with the contour line image on top of those two sheets. Using firm pressure on the pencil point, you will then transfer the selected image to the drawing paper. This will be repeated so that when you are done you will have two copies of the image. On one image, you will indicate the numbers that signify the shapes of the project. The other copy will become your drawn interpretation of the photograph.

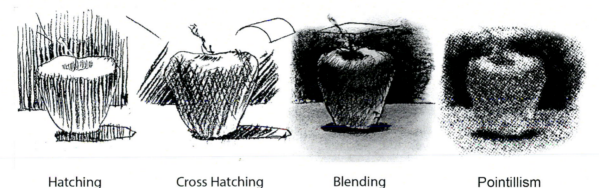

Hatching Cross Hatching Blending Pointillism

There are four texture techniques that you can use to do the interpretation of the value shapes in the photograph:

- A blended or toned effect can be used to create transitions of tones to represent subtle changes within the defined shapes. Use the paper blender or paper stump.
- Pointillism is an approach that uses a variety of sizes of small dots. With the use of pointillism, a visual grainy texture can be developed.
- Vertical lines evenly or unevenly spaced will generate an overall visually exciting, texturally implied, image. With this approach, the termination of drawn lines defines the edges of the shapes and imply the form. Also, if the lines are spaced evenly an interesting silhouette of the subject or shape appears.
- Hatching or crosshatched approach. Diagonal marks develop a gray or dark value effect depending on the closeness of the lines.

Select one or more of these approaches and interpret the drawing. Your objective is to achieve a likeness to the photo by using these textural effects. Refer to the examples given on the next few pages for ideas on the use of these techniques. Review the DVD on this information and go online to research artists that work with these approaches.

Line Control

Below is a diagram to assist in exercises to learn consistency, line control, and massing of lines to create tones.

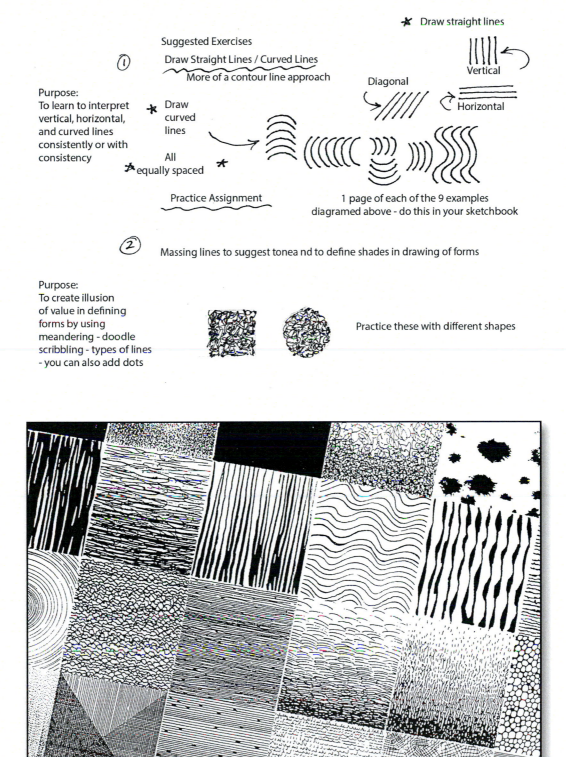

Suggested Exercises

① Draw Straight Lines / Curved Lines

More of a contour line approach

✱ Draw straight lines

Vertical

Diagonal

Horizontal

Purpose:
To learn to interpret vertical, horizontal, and curved lines consistently or with consistency

✱ Draw curved lines

✱ All equally spaced

✱

Practice Assignment

1 page of each of the 9 examples diagramed above - do this in your sketchbook

② Massing lines to suggest tone and to define shades in drawing of forms

Purpose:
To create illusion of value in defining forms by using meandering - doodle scribbling - types of lines - you can also add dots

Practice these with different shapes

Examples of the Photo Piece Project

These examples demonstrate the steps of shape and value blending and the interpretation of tone and hatching.

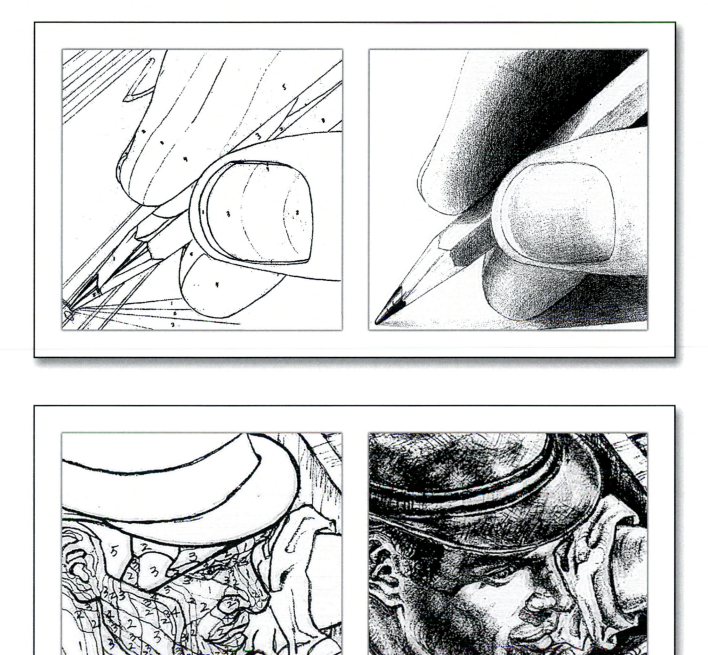

Examples of Pointillism and Hatched Lines

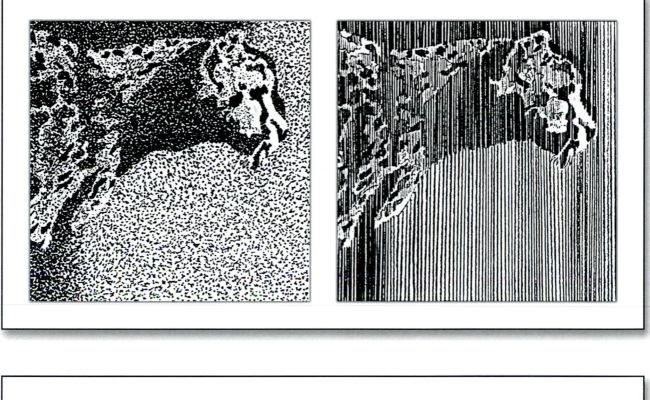

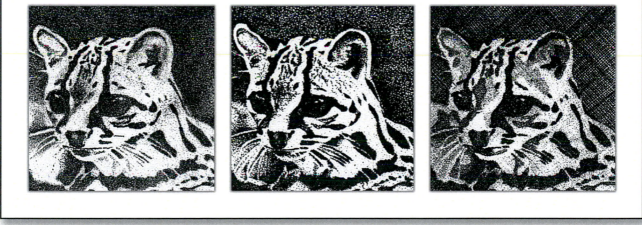

Examples of Hatched Lines

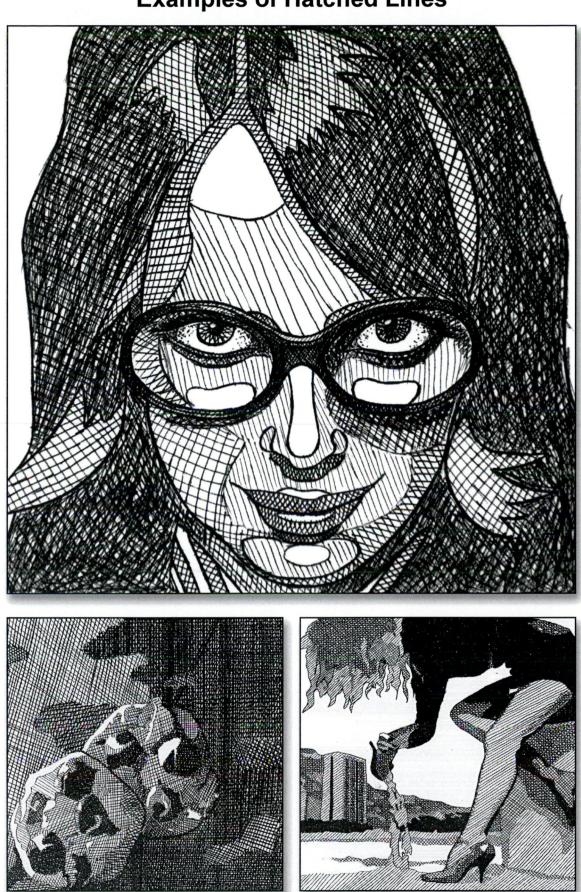

White on White

The lesson in this project will enable you to:

- Define the function of light.
- Understand that values can be isolated and identified.
- Control values in depicting form.

This project continues the study of value. It has to do with observing the value in actual forms, and the influences leading to that understanding. Value, as defined previously, is one of the visual elements of art that defines the aspect of lightness or darkness of a form. This project is about this contrasting appearance. It involves taking a 4" x 4" inch piece of white paper and twisting it to create angular distortions and creases. You do not want the paper to have too many creases. You want a simpler form. This paper is then placed on a white background. As you will notice, some of the white paper folds will appear to be lighter gray and others darker. The values change according to the angle of the different planes and how they are illuminated by light.

The objective now is to begin the actual drawing. Look at the form before you and determine the overall shape that contains the paper. What is the configuration of the form? Draw that folded shape. It can be lightly done. Revise it until it appears to be correct. Next, begin to break down the inner structure within the shape into smaller segments. Once this is done you are ready to begin toning the drawing.

You will follow the same procedure that you used in the basic value scale, namely, graphite applied to the drawing surface with cotton balls. In this drawing, you will rub a value two over the whole area. Next you will restate the line drawing, making it a little darker. Following this you will observe, isolate and identify the appearance of the different segments or shapes. How dark or light are they? Your reference for this will be the value scale that you developed in the first assignment. What you decide will give that shape a value number and will determine how much graphite you use. Specific areas that are smaller require you to apply the graphite with a pointed paper stump.

Continue to refine the drawing until you correctly render the approximate values that you observe in each shape of the paper form. Then begin to erase or "SUBTRACT" the tone to expose the lightest values of the shapes.

The final part of the process will be to attempt to eliminate the lines and allow the drawing to have the appearance of the segments meeting, value against contrasting value. If you look carefully, you will notice that the reason you see a part of the paper that is darker, is that the area around or next to that part is lighter. Focus on that. Refer and study the sample drawings for this project. Review the process on the DVD on this subject.

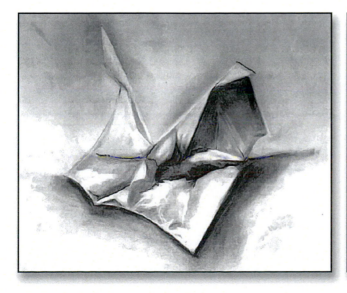
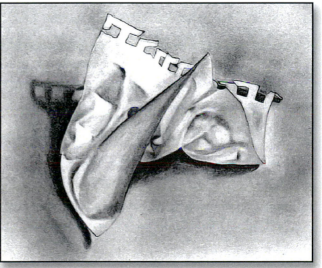

Examples of White on White

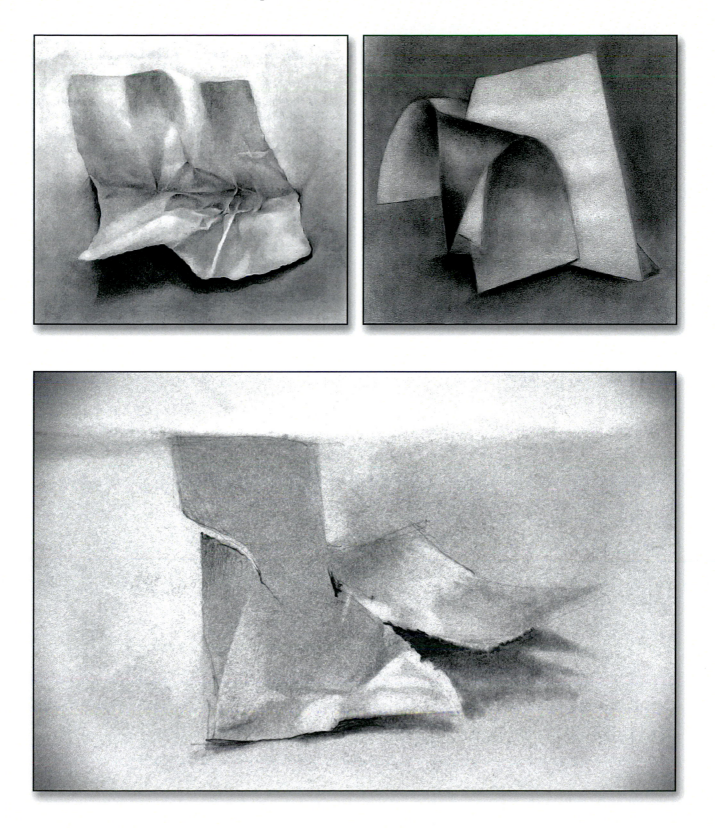

Below is a portrait study in graphite where the lighter tones were erased or subtracted to reveal the form.

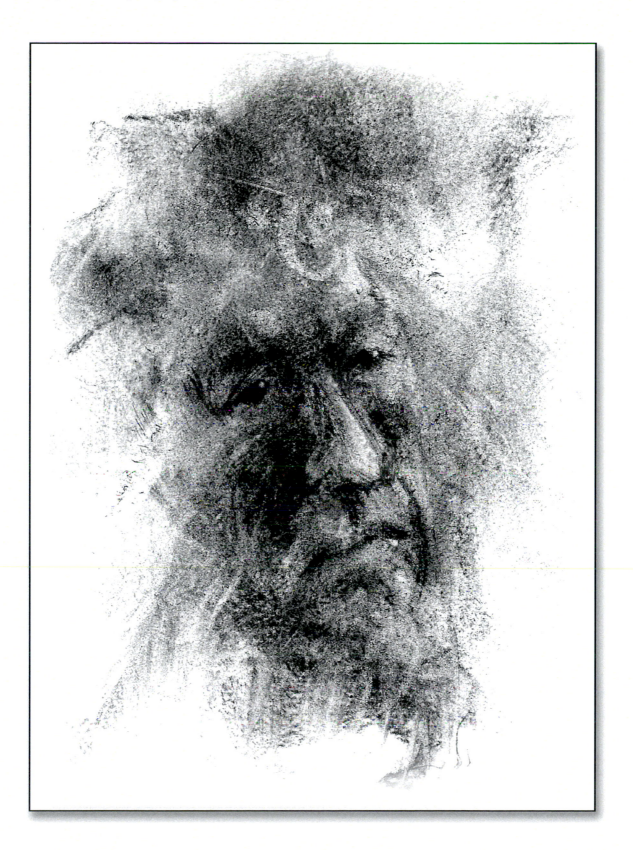

Gray on Gray

The lesson in this project will enable you to:

- Reinforce the toned background as the vital intermediate value in drawing.
- Strengthen your sensitivity to the light and dark value reference in the drawing.
- Facilitate your drawing solutions to real form illusion.
- Create an awareness of "the gray" in your studies.

A study can also be done on gray or toned paper. The procedure will utilize white Conté dust that is applied first and then a line drawing is done with a 2b pencil. The defining of the planes of the shapes then begins with the subtractive process of erasing to get a gray value and then the additive process of adding of black and white indications of form. This process is similar in concept as that used in pastel drawing and painting. In this approach, pastel artists use a toned paper or surface to develop the image. They apply opaque pastel to the surface to render their form, usually from dark to light. Of the three exercises, using a white base for image making is the most often used. A black background is the least used. And the toned or neutral background is most immediately rewarding for a student. In our class, we will combine the gray approach with the use of colored pencils in drawing colored plant forms. Study the toned drawings and sketches by the great masters.

Below is a beautiful portrait study drawn with highlights and shadows to create contrast on a toned surface.

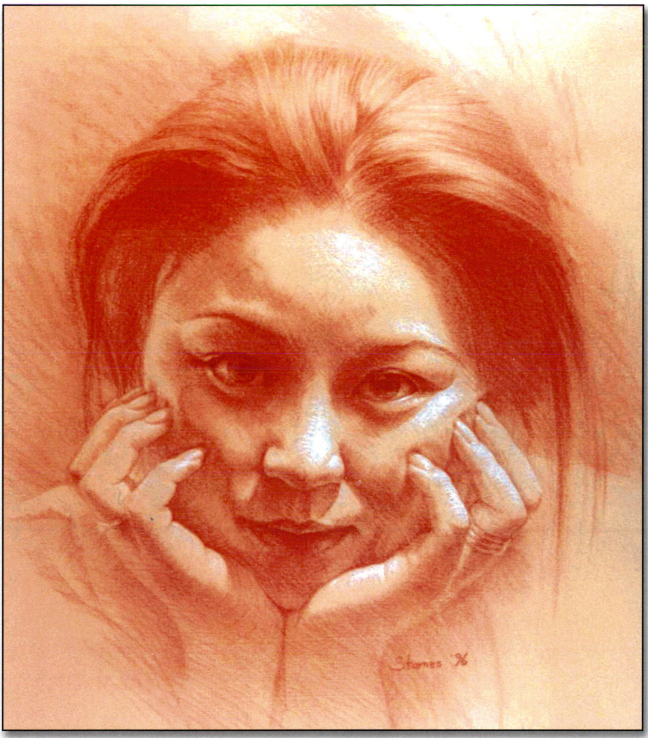

Black on Black

The lesson in this project will enable you to:

- Develop an awareness of a dark background format in drawing.
- Identify correct light value introduction in developing forms in dark compositions.
- Develop confidence in attempting dark value compositions.

The opposite of the white on white project is also a worthwhile study. In attempting to draw a dark object on a dark background, an equally demanding situation confronts the artist. On a black on black paper drawing, white Conté dust is applied on all the background to achieve a 25% value of gray. A drawing is then established on the surface with pencil and then a kneaded eraser is used to erase and begin to indicate correct dark value shapes to identify the planes of the forms. White is then added for the contrasting lighter values. We might say that in doing so, we tell the viewer where the light is and is not. Continue the process until satisfied with the image. White Conté is finally introduced in the areas where you see the greatest light contrast. Refer to the drawings for this project and review the DVD for the demonstration on this project.

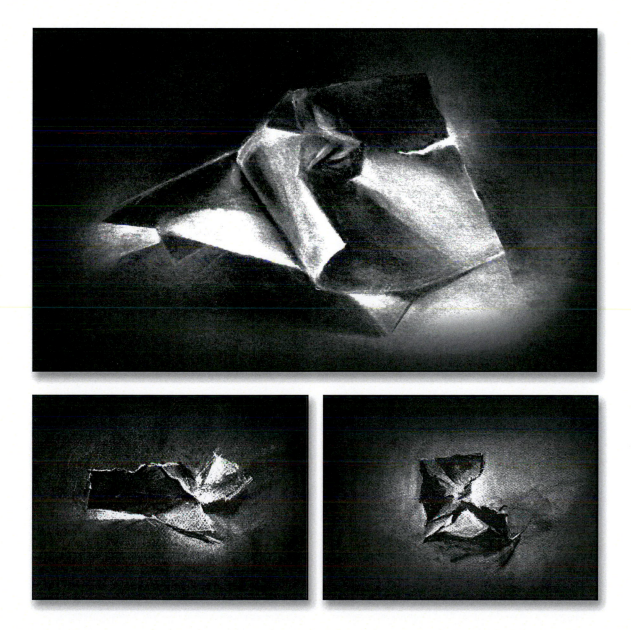

Section IV: Color

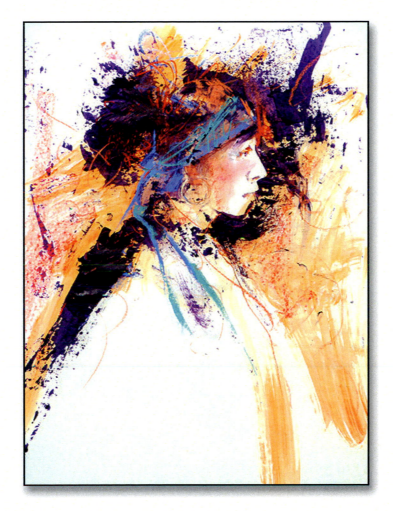

Color Mixing

In this section, you will experience the basics of color mixing using Col-Erase Pencils. These colored pencils can easily be blended and are considered transparent and erasable in contrast to Prismacolor Softcore Pencils that are more highly pigmented and are a little more challenging to blend. In the world of color mixing, the primary colors of cyan (or blue), magenta (or red), and yellow, are used to make colors of the spectrum.

Using these pencils will be our first exercise of creating mixtures of these primaries to render what we see. The second part of the exercise will include mixing black and white values with color to create tints and shades. The third part of exercise will test your ability to apply color and value to line drawings to create the appearance of three-dimensional forms. Please use this color wheel as a reference, and the small black and white wheel is an example of what happens if you remove all the hues from a color wheel and only have dark and light values.

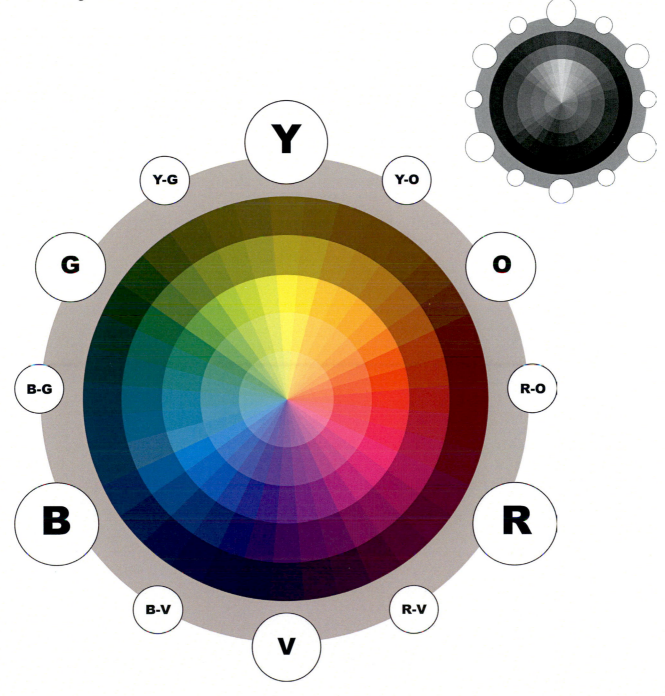

Basic Color Wheel

A variety of tones and tints can be created after learning the basic mixtures of the primary colors, red, yellow and blue. Try to use only these three colors on your color wheel to create the secondary colors: mixing primary red and yellow to obtain orange; yellow and blue for green; red and blue for violet. After mixing the secondary colors, you can then mix the final six tertiary colors.

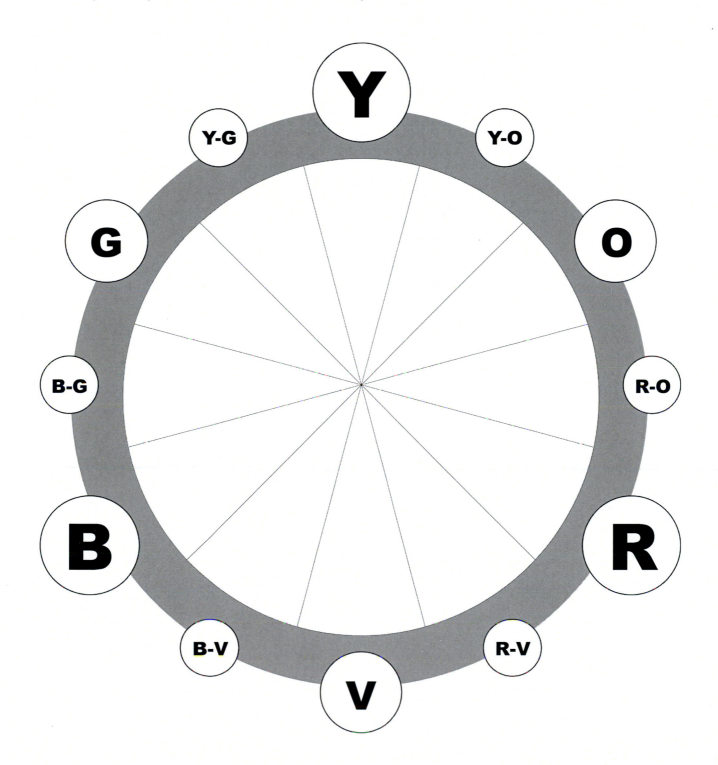

Color & Value Chart

- Mix red and yellow to obtain orange, yellow and blue for green, blue and red for purple.
- Color in the Black, the Shade, and the Hue sections at the same intensity.
- To darken the hue, use a graphite pencil and cover over the Shade and Black sections, and then once more cover the Black more intensely to further darken the hue.
- For the Tinted section, simply add color with a lighter touch. You can erase color if it appears too dark.
- For the White section, simply apply color with the lightest touch, giving just barely a hint of color.

Value Ref.		Black	Shade	Pure Hue	Tint	White
	Red					
	Orange					
	Yellow					
	Green					
	Blue					
	Purple					

Color & Forms

Attempt to give these two-dimensional line drawings a three-dimensional effect by adding color and value. Use the value numbers as reference for light and dark contrast, 1 being lightest and 5 being the darkest. You may use any color on these studies. Refer to examples on the next page.

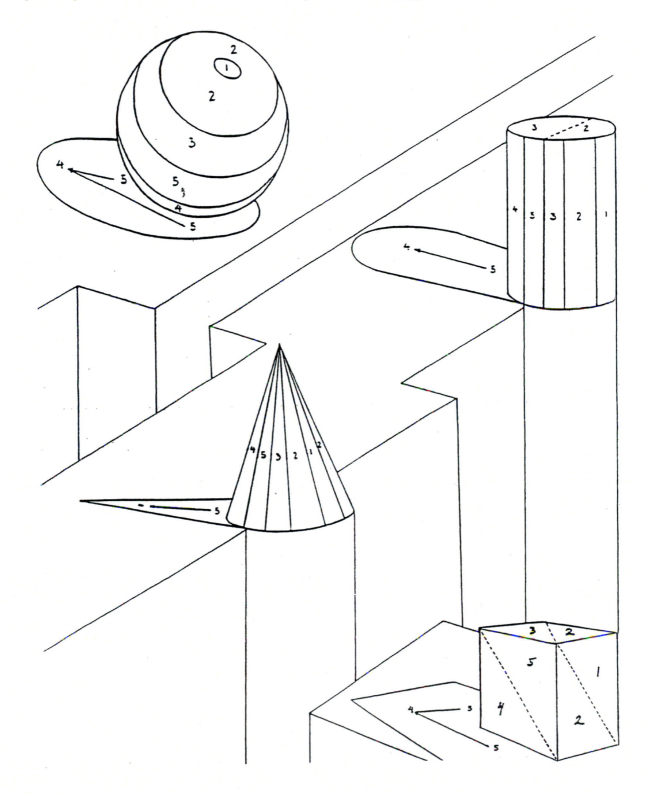

Examples of Color Mixing

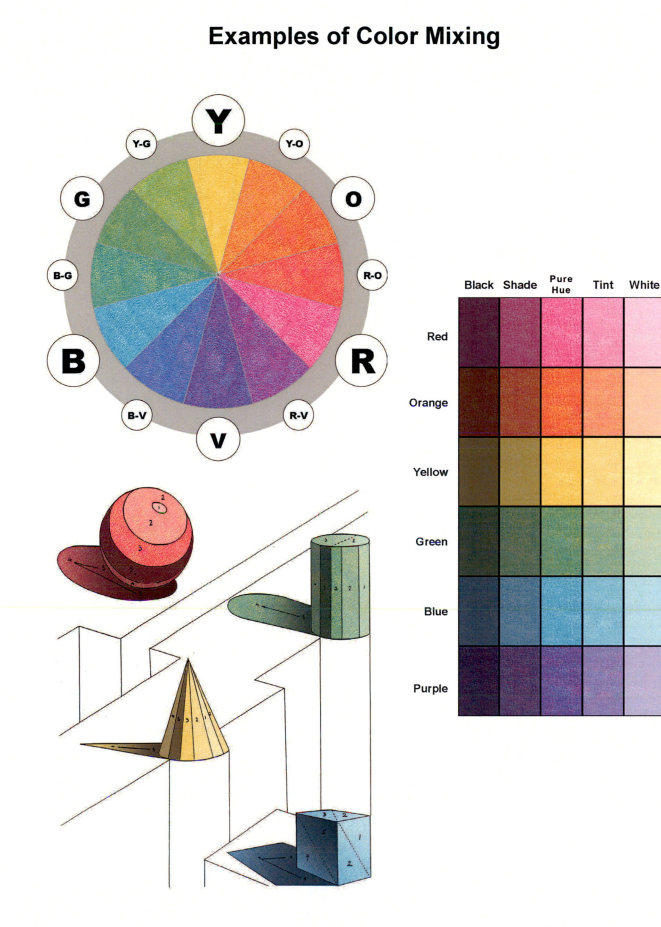

Examples of Color Drawings

A great example showing the process from a line drawing, to a value study, and to the final colored image.

Line

Value

Color

© Thomas Starnes

Colored Still Life

The lesson in this exercise will enable you to:

- Identify and manipulate the elements of color.
- Mix the colors you see with the primary colors.
- Understand the function of light in color perception.
- Experience the dimension of color transparency and opacity.

When we think of the word "color" in the simplest of terms, it helps to think of what is not colored. This will help understand the definition of what color is . We have already done this in our study of light and dark value. Now we want to attempt a connection with our experience of illusion making that will evoke a different visual response.

This connection will happen as we address the separate elements of color that were mentioned when we began our study. Remember, they are Hue, Intensity, and Value. Hue is a reference to the color itself with no other qualifications. Intensity or Saturation gives the sensation of brightness or dullness of a color. And with Value, we understand contrast. An example of the color elements together would be a child's toy that is described in color as a dark, bright, blue toy. Additionally, the connection is understood more when we equate the different levels of transitional colors of blue on the toy to the different scales or levels of gray.

What we are alluding to here is that there is a definite counterpart for each color in the value scale: dark purple or dark green is the same as a dark value, a light pink or a light orange is the same as a light value.

Now the Connection!

The challenge for the beginning student is to master the skill of seeing value and color and then making the critical connection of the visual "sameness" of these in observed forms. The practice in the form- scale exercise that we did with value will assist you in this. Refer to the example given on the next page. Notice the sphere having sections numbered 1 through 5. When we did the study of value, #5 was very dark and #1 was light. Now adding color to this exercise, we will combine a #4 or #5 dark value graphite pencil with let's say the color blue to create the color dark blue. Conversely, when adding blue pencil with little pressure, we create a light blue. Then adding the transitional colors and values we create the illusion of the solid round sphere. So, remember, as I mentioned previously, Observe, Isolate and Identify what you see…Value is there, Color is there and Light is there. We now want to recall another link to our discussion. As I have just stated, "Light is there ". We must remember the importance of the presence of light.

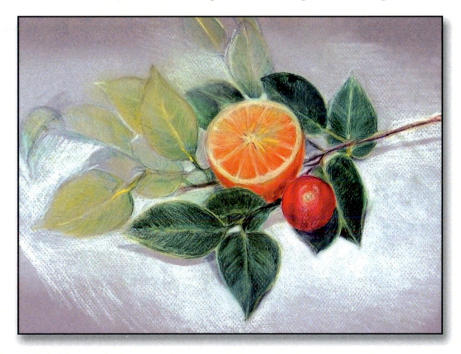

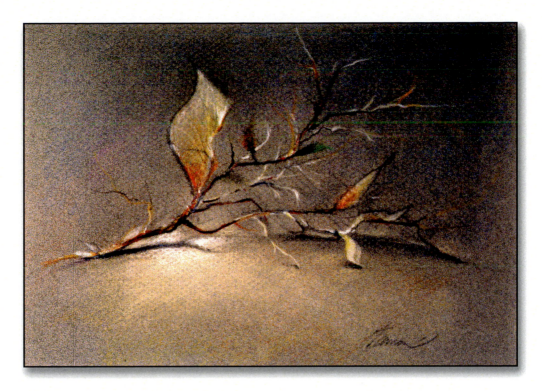

Light allows us to see the beauty of colors on forms. Without that presence, the clarity of forms is not available to our eye. As light reaches an object, reflection of the light waves not absorbed by a perceived form are received by the eye and transmitted to our brain. Then, every aspect of the form, from the planes, textures, shadows, and the usually disregarded qualities are now better observed and understood. It is because of the Light that we SEE.

Now look at the medium we are using to draw, the pencil. I have asked you to buy a set of primary colors, Rose or Magenta, Lemon Yellow, Sky Blue, and a stick of Conté white. The intermixture of the primary colors will give us the range of colors to interpret any form. The brand of pencil Col-Erase is used in our exercise because it is erasable. Since it has that capability, colors are easily modified or altered to achieve the correct results. A contrasting product that is not transparent, but opaque, is the Prismacolor pencil, which is less easily modified because it is wax-based. The Prismacolor pencil is used in this exercise at the end to enhance the intensity of colors when necessary.

The procedure for this color project requires that you first do the color wheel exercise to familiarize yourself with color mixtures. After this, you will begin by drawing an interpretation of a vegetable or fruit using the Gray on Gray paper method (page 51). You must first apply the white Conté powder to the surface area that you will be using to draw the fruit. You will then draw the form using the analytical approach that was used on the white on white exercise. The difference is that with this approach, you will use the Conté stick or pencil to put extra white under the areas that have the greatest color contrast. It is as if you are doing a black and white drawing.

After this is accomplished you will determine the dominant color of the form. For example, if colors are blue-green, green and yellow-green, the dominant color is yellow. You will draw in sufficient yellow base color on all the drawing of the form. The next step is for you to begin slowly and lightly to introduce a blue, that will allow the green color to begin to emerge. This step is repeated until you are satisfied with the level of intensity and value of the green.

To darken the colors, you may add regular graphite pencil, since it intermixes well with Col-Erase pencils. The darkened colors will be enhanced by introducing magenta or rose into the blue or yellow. Remember that all the colors together, mixed with the same pressure will give a rich dark color mix that is full of life and not dull, like black sometimes appears. If you need extra intensity, the Prismacolor pencils may be used. Refer to the DVD for the demonstration and procedure of this color project.

Examples of Colored Still Lifes

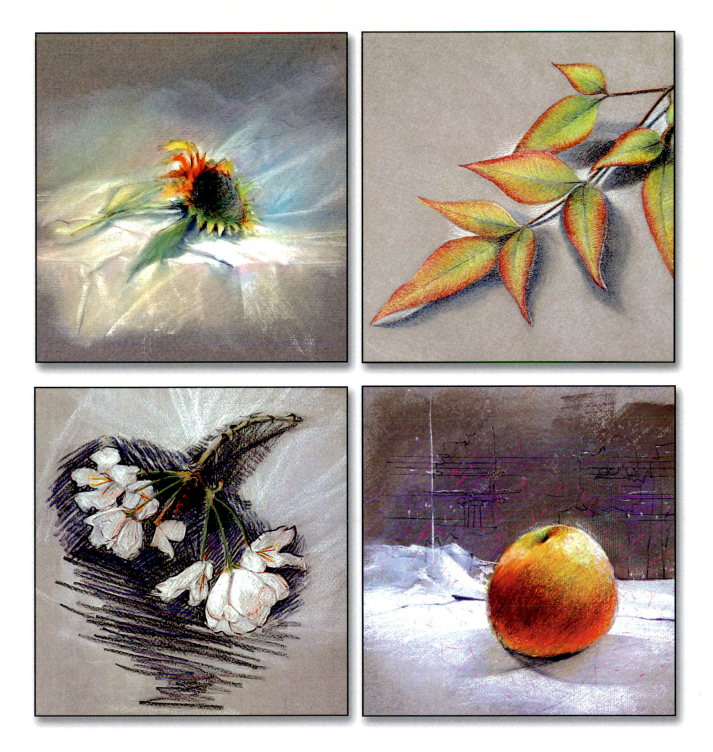

Below is a portrait study drawn on toned paper with colored pastels. The neutral background creates contrast with the light and dark vibrant colors to allow for a dynamic image.

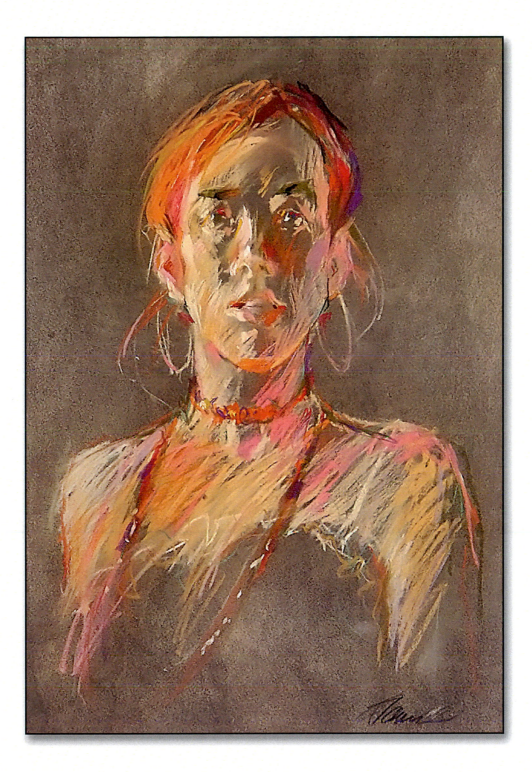

Section V: Texture & Ink

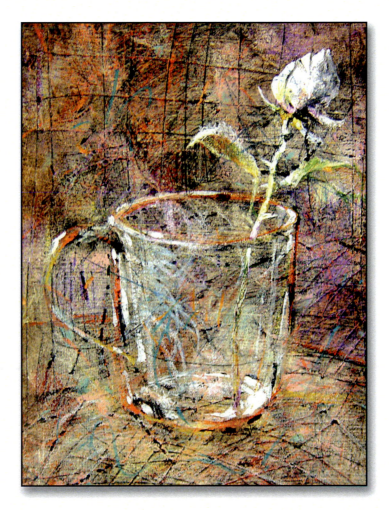

Texture

Texture is the surface character of an object. All objects have a surface character, even if it is just smooth. Texture is an important consideration in most areas of art and crafts. A crafts person and artists often rely heavily on the texture of the materials they use to enhance the effect of their designs and paintings and to create textural variety. In drawing artist can also create the effect of a rough textured surface, for example, by using different techniques like dabbing sponges or textured materials dipped in ink or paint and applying them to a surface to suggest the roughness of stone. There are two categories of artistic texture—tactile and visual.

Tactile Texture

This is real texture that can be felt. In jewelry, ceramics, collage, furniture design, architecture, sculpture, etc., the materials used have a variety of tactile textures (e.g., sand, rice, grass, etc.). In painting, using thick pigment creates an uneven surface, which is a tactile texture.

Visual Texture

- Simulated: In painting, the element of texture is visually illustrated by making use of surface contrasts to provide visual interest. There is no actual texture there, only the impression of texture on a flat, smooth painted surface. You cannot feel it. It is a visual illusion, a suggestion to our eyes. It is often defined as simulated texture.

- Hyper-Realistic: The ultimate, hyper-real, portrayal of visual texture is called trompe l'oeil (French for "to fool the eye".) It is commonly defined as "deceptive painting" because the appearance of objects is so skillfully and realistically reproduced that we are momentarily fooled. We have to look closer to see that the image is not an actual object, but a painting.

A major consideration of working with texture is the balance of texture in the composition, that is, the amount of texture and how it is used throughout the composition. An imbalance of the texture would be where a drawing has a great amount of bold texture in the background of a portrait and the opposite amount on the rest of the work.

People are often uncertain of the difference between texture and pattern. Pattern is the appearance of an organized motif, or repeated marking on a surface. While texture has to do with variation, with whether the surface provides tactile changes, pattern, in contrast, has to do with regularity, with whether a work repeats itself over and over again. In other words, every texture makes a sort of pattern, but not every pattern, could be considered a texture.

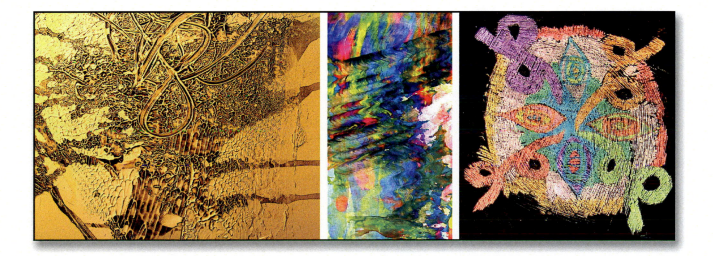

Examples of Textured Artwork

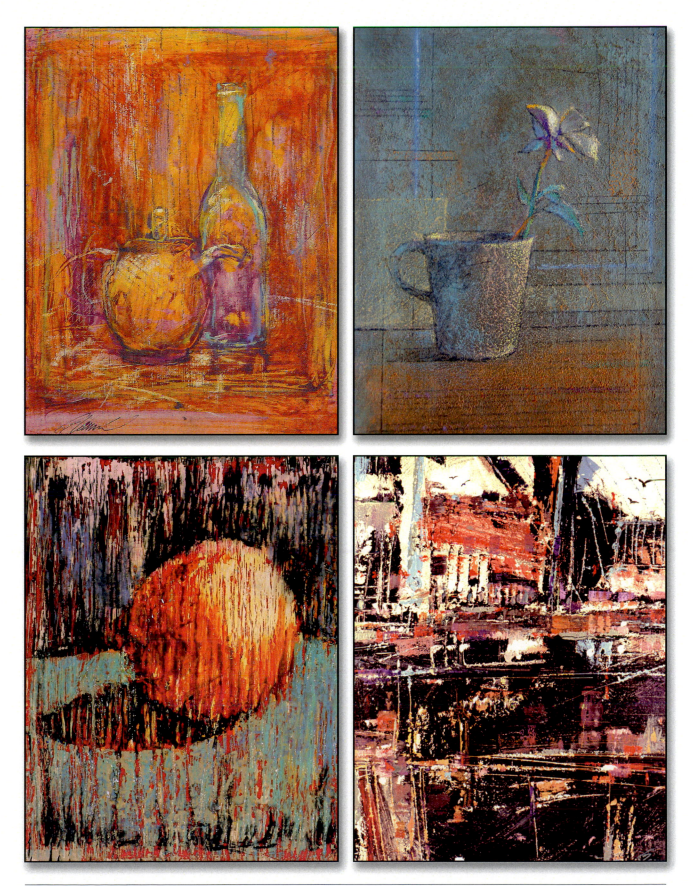

Ink

In this section, we continue to explore the illusion of visual forms. Now we will explore the possibilities of visual texture using ink and shading techniques - hatching, crosshatching, meandering, dots, smudges, etc.

Perhaps you have held in your hand the medium with which you would familiarize yourself and by which you would understand this word "ink." If you consider the character of it, you would correctly and simply define its essence, by saying, "It is a liquid of some sort." This answer is sufficient to begin our inquiry and leads us into the next step of our study, WET MEDIA APPROACHES. But first a look backwards.

We have just spent a significant amount of time exploring a small part of the world of dry media in our study of pencil applications. We attempted using this medium to explore and understand the element of value quite extensively. The study reinforced, with each succeeding project, the control an artist can accomplish with pencil, from the theory of value as scales to a finished representational colored drawing of form. But let us now go forward in an opposite direction using ink, which is working with the wet media consistency of ink. We want to understand the potential of this medium and consider its unique and creative possibilities.

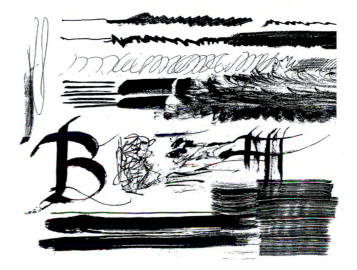

Line Variation

First, what is the character of ink besides its liquid nature? Why does some ink dissolve and some ink remain permanent? The research work of art material experts like Ralph Meyers and Frederic Taubes provide the knowledge about the makeup of ink in contrast to paint revealing to us that ink is composed of dye and it does not contain pigment. In contrast, some ancient pigment compositions were dyes, according to Fritz Henning:

"Lakes, this incongruous art term comes from lac, the Indian (India) name of a variety of tree-feeding insects. The residue of the lac left on trees is the basis of shellac. Unrefined grades of lac are a deep red and are used to make dyes. Also, it should be noted that in ancient Italy the impurities collected from dyer's vats were used as a pigment."

The comparative tests from Henning's research suggests that India ink, sumi ink, oil, alkyd, acrylic, and the best grades of watercolors had no discernible change in permanency compared to the dramatic fading over time of colored inks and concentrated watercolors. On the other hand, Henning concluded that the Prayer book of Maximilian I is evidence that some ink work has lasted for centuries. Interestingly enough, we currently find inks with pigments, called pigmented inks, and pigments with chemically produced colorants.

Ink makers during the early 1400's developed a permanent ink from the soot of the beech wood. Much of the work of the Renaissance masters remains today because of that discovery. The development of a different ink during the latter part the eighteenth century resulted from exploration with cuttlefish secretion. Sepia was the result. This ink was not light fast, and the work ultimately faded when it was exposed to too much light.

The ink that is widely used today, India ink, is a carbon-based black liquid containing gum, shellac, borax, and stabilizing solutions. It is very permanent and effective; similar, interestingly enough, to the ancient ink developed in Egypt and China two centuries ago.

EXPRESSIVE DRAWING

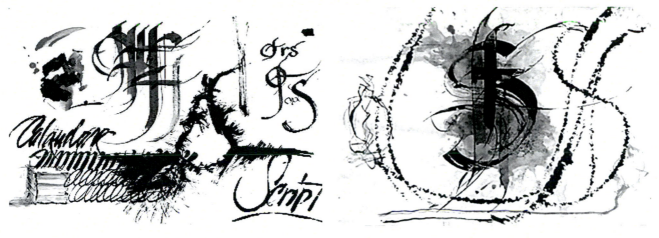

Below is an example of materials, supplies, and non-tradional applicators that can be used with ink to create amazing works of art.

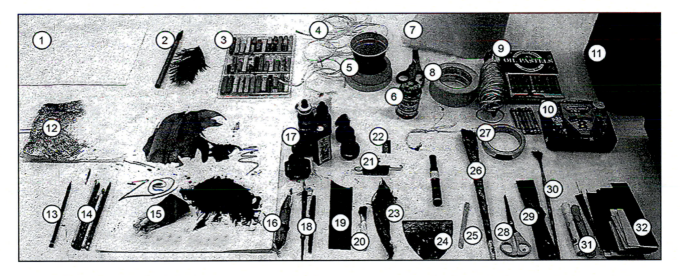

1. Watercolor Paper
2. Chinese Watercolor Brush
3. Dry Pastel
4. String
5. Cup
6. Rubber Cement
7. Paper Towels
8. Masking Tape
9. Oil Pastel
10. Crayola Wax Crayon
11. Water Container
12. Dry Towel
13. Pencil
14. Color Pencil
15. Paper Brush
16. Bamboo Pen
17. Permanent Ink
18. Ball Pen & Non Perm. Pen
19. Strip of Rubber
20. Taped Brush Towel
21. Spring
22. Razor
23. Old Burlap Fabric
24. Broken Spatula
25. Stir Stick
26. Old Paint Brush
27. Tape
28. Scissors
29. Steel Spatula
30. Fan Brush
31. Colored Makers
32. Mat Board Strips

Examples of Ink Work with Lines

Dots & Vertical Lines

Implied
Shapes

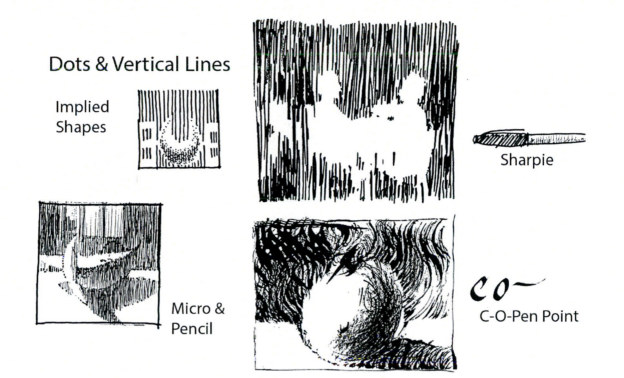

Sharpie

Micro &
Pencil

C-O-Pen Point

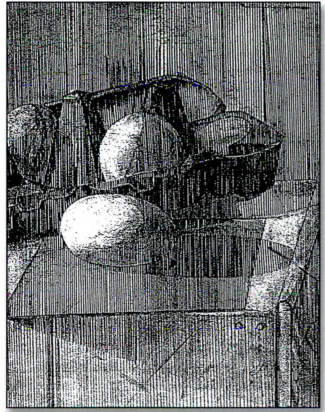

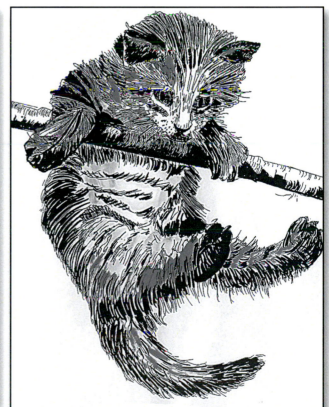

Examples of Ink Using Pointilism & Hatching

© Thomas Starnes © Thomas Starnes

Ink Application

Transitions and Sequences of Values Pt. 2
The following information is closely related to page 40 - The Language of Value: Transitions and Sequences of Value

The lesson in this project will enable you to:

- Experience transitional tones or scales of black to white by adding water to ink.

There are two approaches on interpreting and understanding how light falls on different surfaces and varied planes. First, we can observe a light-valued round, smooth form, like an egg. The value changes that occur on the egg are transitional and gradual. Conversely, an open white cosmetic box with different compartments will have to be interpreted with areas of different value planes, some will be lighter, some gray and some darker. We refer to this approach as sequential.

To begin this exercise, you will need Higgins Black Permanent Ink, 1 small cup of water filled about a quarter inch high, and a watercolor brush. We will begin with a sequential 1-5 value scale like the first exercise in the Value chapter. Our first step is to make our value #1, simply add a single drop into the cup of water and brush on another piece a paper with a 2-inch diameter to see if value #1 is visually satisfying. Now add a few more drops of ink into the same cup to darken the values. You can overlay many washes to darken the value; but be careful, once you make your mark with permanent ink, you can no longer correct it. Repeat this task until you have completed a basic 1-5 value scale with ink washes. Once dry, cut out the ink washes into a 1 inch x 1 inch square and paste them on a standard size piece of paper, leaving room for the next value scale which will be the transitional value scale.

To begin the transitional value scale, start with a new cup of water and repeat the first step in making a sequential ink wash value scale, but only this time you will be brushing 6 inch in length and 2 inch in width. Apply the ink and remember where you start will be your darkest value and where you finish will be your lightest value. Repeat this as you gradually add more ink to the cup to make it darker. Lift the brush off more often as you get closer to the darkest value. Once you are done simply cut out a paste your transitional value scale next to your sequential value scale and see your attempt at ink wash.

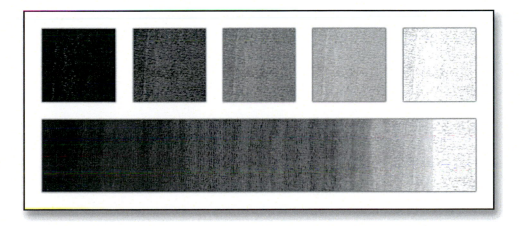

Examples of Transitional & Sequential Ink Application

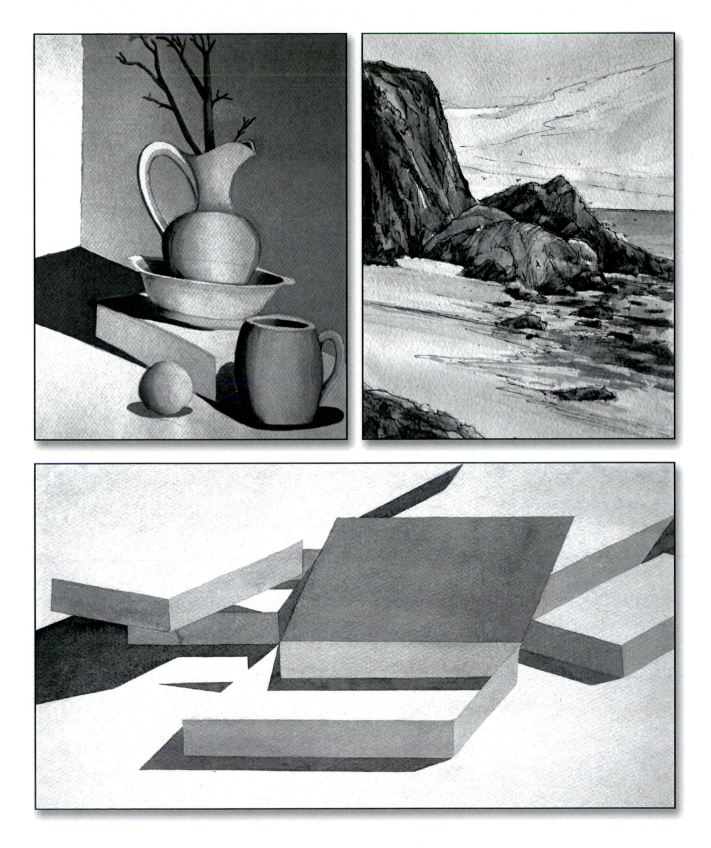

25 Marks

The lesson in this project will enable you to:

- Experience familiarity with the variety and the potential of different ink densities.
- Create value changes from light to dark with new tools.
- Explore non-traditional applicators.

A safe way to begin this project would be to use a pointed brush, a felt tipped marker, or a fountain pen. However, the approach that we will take is to use applicators that are not customarily known as inking tools. The reason for doing this is to help a student realize that just about anything that they can rub on a surface could be used to mark that surface. The second, and possibly the most important reason is to break formality, to break custom in the drawing process and mark-making. Strings, spatulas, plastic spoons, scraps of mat board, paint rollers, the ink bottle or just sticks can be used to draw. I tell my students that a trip to a trash can in the art department can reward them with interesting "marking tools".

The focus now is to experience a variety of lines and the changes that can be created in mark making. Just the manipulation of the hand will greatly alter the effect. In doing this exercise you will know, understand, and be able to do something without specific control, and that is acceptable. A sustained position of the hand or angle of the tool can be repeated to create a pattern or an overall tone on the surface of the paper. As the ink begins to dry out, the marks will also become lighter or grayer. Doing this again, you can repeat the effect of grayness on the paper. It is a challenging and rewarding exercise.

So, begin the exercise. Attempt twenty-five different marks and then attempt a drawing of a simple object from your sketchbook or from a real form, using any of the suggested applicators.

Refer to the drawings given and the DVD on this project as you practice this process with each tool you select. Have Fun!

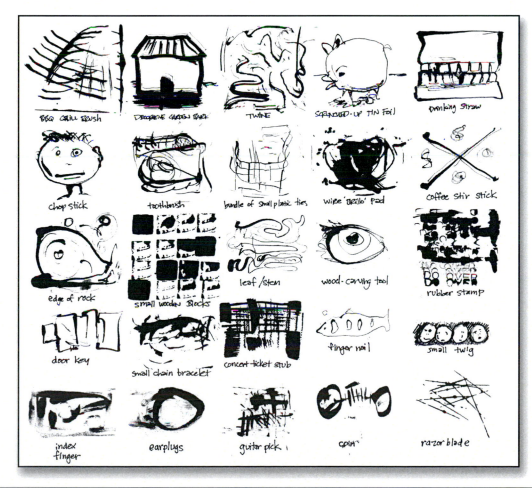

Examples Using Non-Traditional Applicators

Below are some examples of images with strong texture.

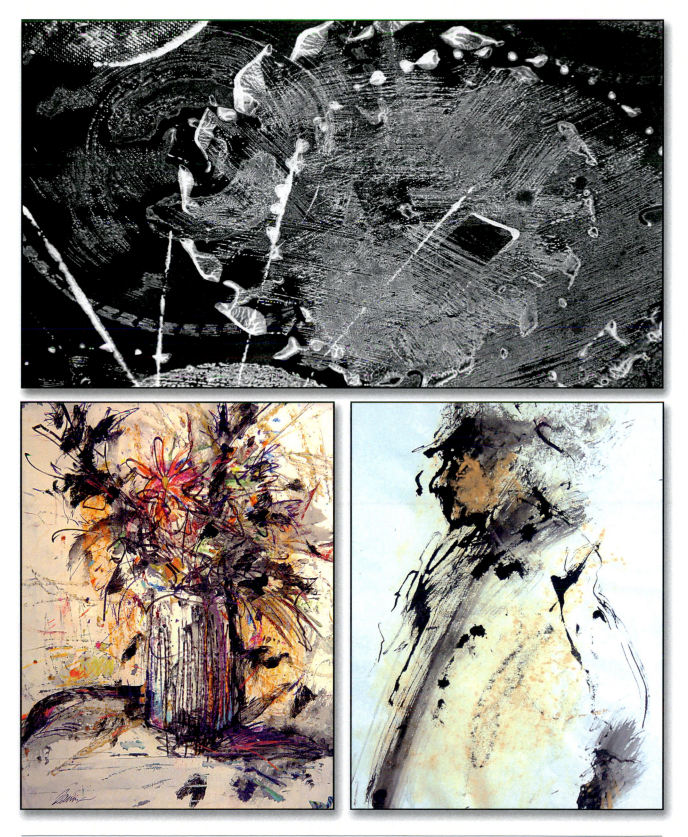

Opened & Closed Composition

The lesson in this project will enable you to:

- Employ ink to create contained and not contained artwork.
- Apply this experience to other wet media.

In working with this approach in drawing, a student is confronted with breaking another barrier. Typically, an ink drawing that represents a real form visually defines that form within the limits of a symbolic shape structure. This is important. The structure is represented in the limit of the shape. For example, a red apple is drawn in black and white, by creating an outline of the apple and then introducing a dark application or tone within in the outline of the apple. After this is done, the artist proceeds to lift off some of the ink to suggest where the form is lightened and adds darker tones to define areas that are shaded within the form. Then, the cast of the shadow is added to reflect the angle of the light source. Finally, the addition of linear marks to represent the texture of the apple's surface will finish the drawing. The image that is drawn within the "limits" of the outline, is a closed composition drawing. It can be easily observed that most traditional art work, from paintings, drawings, sculpture, ceramics, and architecture, fit this category.

BREAKING THE BARRIER

This is where it gets exciting. You will discover that you can do a drawing, where you can go "beyond the lines" and where you can express the essence of the form freely and without restriction, except for your own intentions. You will feel a new and enjoyable involvement with the process. This happens in an open composition format of work. It is non-traditional, unpredictable, boundless, and liberating. You are going to enjoy this method of drawing!

Select an object and create two drawings one with a closed format and one with an open format. The drawings below illustrate this concept. Another way of thinking about open and closed is to relate closed to realism, containment, or limited shapes or forms. In a word, drawing things as we see them. An open approach may represent forms that are expressive, non-objective, not contained nor limited.

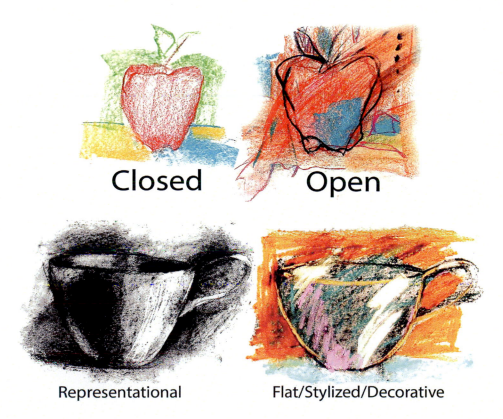

Closed Open

Representational Flat/Stylized/Decorative

Examples of Open Composition

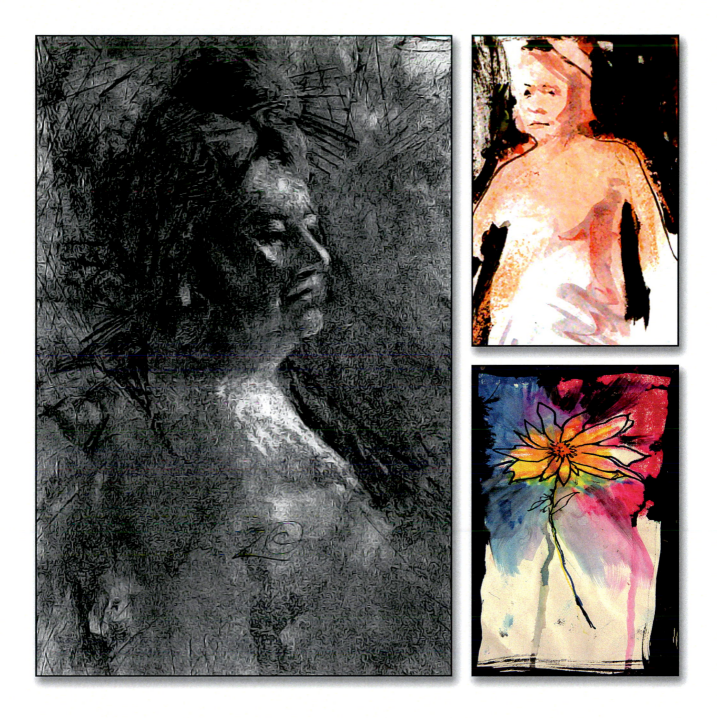

Examples of Closed Composition

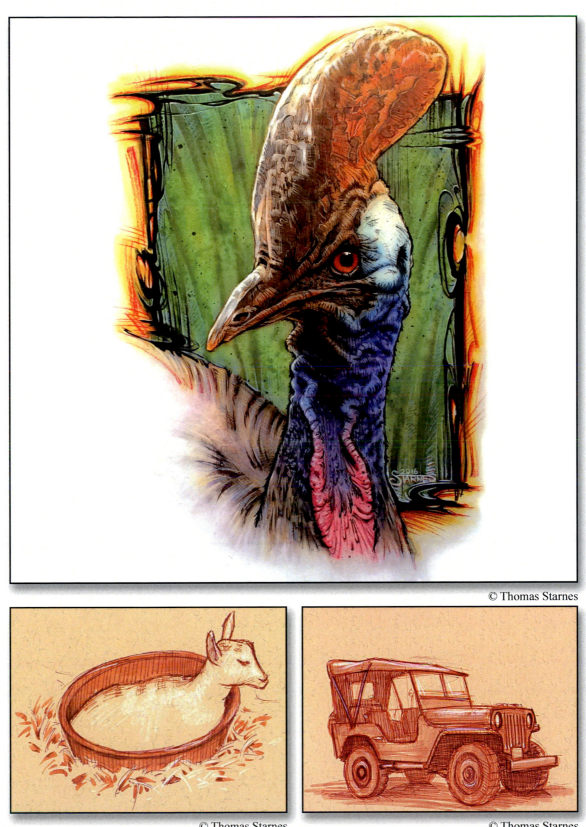

© Thomas Starnes

© Thomas Starnes

© Thomas Starnes

Expressive Media

An approach that is at once liberating and conducive to expression is the ability for an artist to make and control the flow of any medium. In working with ink, students find this aspect especially challenging and rewarding. With the application of the ink a student can sense the "character flow" of the ink on a dry or a wet surface.

On a dry surface, the ink creates an immediate stain and holds the edge of the mark. When applied to a wet or moist surface, the ink immediately disperses leaving a varied, amorphous or unstructured stain. It is important for the beginning student to experience these contrasting "languages" of ink that can reward the artist with the possibility of discovering appealing images. Let us look at these more closely.

Wet onto Dry

The wet-onto-dry approach is the typical way ink or wet media are applied to a surface with an applicator, be it pen or brush. As stated above, the character of the lines produced is usually a singular solid mark, unless an artist uses a very loaded brush on its side and drags the brush on a rough surface. The resulting effect in this case, is a "dry brush" or a broken edged application that is rich in texture.

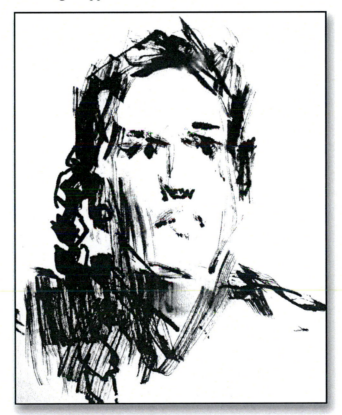

With an ink pen, an artist can use a single line, like the contour line drawing approach, to suggest an image. This is an accurately expressed line with no variation. It is like a mechanical line. This method of drawing develops an artist's skill in observation; the focus being the definition of the edge of perceived or imagined form.

Simple line is also used in architectural drawings, now done on computers. Diagrammatic directions for the assembling of household or industrial products also use line drawings. The majority of artists use line in sketching on location and while just doodling. In print-making, in the acid-etching process, a metal tool, the burin or a sharp needle is used to incise lines into a metal or plastic plate. Native American Indian potters use sharp tools to scratch beautiful linear designs onto their polished black ceramic pots. Glass artists and designers use Dremel tools to etch linear patterns and images on the surface of their creative works.

Another customary application in the drawing procedure is the use of many kinds of marks like hatch marks, doodles, smudges, or dots. Employing hatch marks, an artist can create a variety of tones or various degrees of darkness in modeling form. The effect of closely applied hatch marks is a dark tone. As the artist leaves more space between the lines, the tone lightens.

Dots or smudges of ink can also be used creating tonal effects, but careful attention must be paid to the amount of white that remains in the image. The white space must function with the ink application to accomplish the correct tones.

These approaches of line application all work together. They are inseparable and embody the drawing process. To clarify: marks that are linear, defining observed objects, or hatch marks resulting in toned areas that are symbolic shapes, all create the illusion of forms.

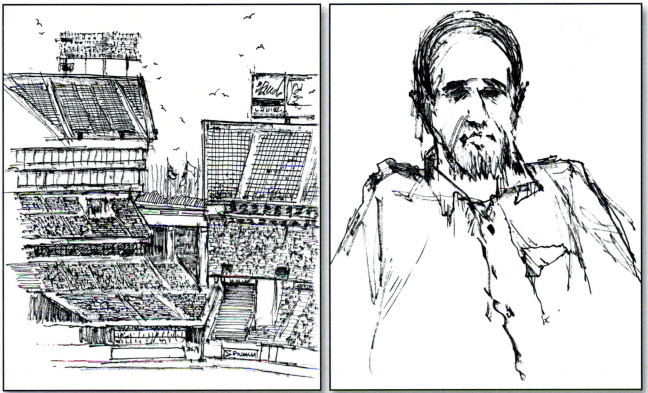

Wet onto Wet

Next, we consider another interesting possibility, the uncontrollable flow of ink as a means of expression in a drawing. Included in this approach is the exploration of lost and found edges of forms that can be related to the Open & Closed Compositon method. This approach is the opposite of the dry surface effects. Although you may use lines to define the object, they will now function along with the carbon dispersion in the water to create the drawing. The resulting transparent effect is created by the amount of water on the surface or that which is absorbed into the paper. The drawing below demonstrates this process very clearly.

Begin by lightly drawing an object on Bristol or, a drawing surface of regular weight because thinner paper will warp due to the addition of water. Following the sketch, add water freely over its surface with a two inch brush. Experimentation can be done with the amount of water application. Then add ink with a small pointed brush. The application of ink can follow the image as drawn. The ink will immediately disperse away from the applied area uncontrollably. If so desired, after a short delay, more ink can be applied to strengthen the drawn line. In this case one must consider the principle of dominance, whether the line drawing still has visual impact or not. If it is weak in appearance the line should be altered to make it more bold.

A second, and equally interesting approach, is to "flood" the paper with extra water and let it sit for a minute or so. Next, with the pointed brush again, freely draw your image. The ink will remain most dense with the image, and the areas around the line drawing will disperse in softening gray tones.

These experiences are invaluable basic approaches that have applications to other media. For instance, in watercolor painting, an artist will create a drawing in pencil, and then begin to add colors on a dry surface. The rendering with transparent colored pigment continues until the brush marks blend or transition into one another for the desired effect. In all other soluble media, such as oil, acrylic, latex, lacquer, dyes, stains, and coloring sticks, similar effects can be attempted.

Transparent washes or glazes can be introduced into the creative process if one knows how to reduce the pigment medium. Knowing this, any surface can be color modified, like my first curious impression of walking into a mall and seeing the colored cement walk ways. Artists have attempted such transparent staining effects in their work with acrylic or oil paints. One such artist, Helen Frankenthaler, created very large stained canvases in the 1960's. Some artists use the staining approach in creating colored supports using wet media on dry surfaces or wet media on wet surfaces, which become the basis on which a painting is developed. This is an approach used for some of my own work.

Your assignment is to create two drawings using these two approaches. Refer to and study the drawings on the next page.

Examples of the Wet onto Wet Process

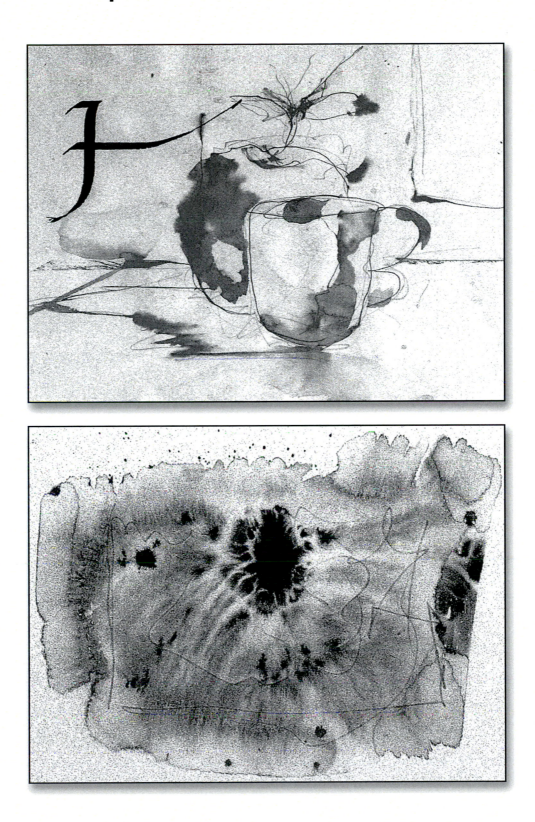

Dry onto Wet

This is the most exciting of the ink techniques. It is unstructured and free and the results are pure surprise. Even with the openly experimental approach, however, there can still be some control. The project reflects the creative use of ink drawing, water, and pastel color mixtures - a mixed media approach.

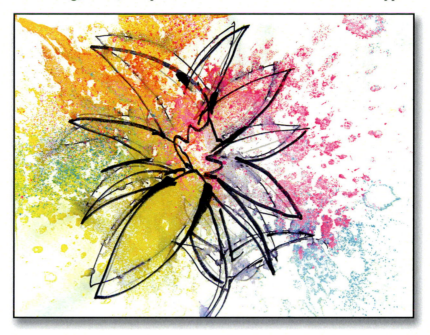

The exercise procedure is simple. First make a line drawing in pencil of several forms or a more complicated composition. Then cover the drawn lines with ink, using line variation. After the ink dries, a loaded brush with clean water is applied to the drawing in specific areas or randomly over the entire surface. Water can also be sprinkled over missed areas. Then, select your colors. I recommend starting with two colors and adding additional colors later, or using a complementary color scheme. You will begin by scraping the color from a dry pastel stick with a razor blade. The color dust will sit on the wet surface of the paper. After the color is added, the paper is lifted to the side of the table and flicked with the finger on the back side of the drawing into a receptacle. The image will then appear. The colored dust remains only on the wet areas including the sprinkled water areas. The effect is like a transparent watercolor with texture over an ink line drawing. This creative technique easily fits into the category of the open composition method of work. Refer to the interesting drawings given and to the DVD for the demonstration of this project.

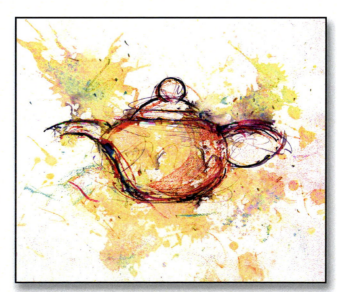

Examples of Dry onto Wet

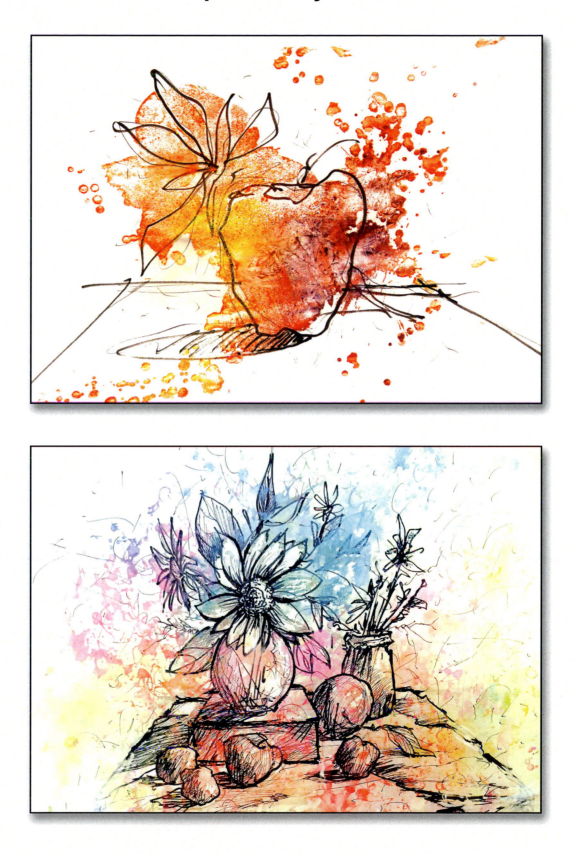

Scratch Technique

When there is a need to produce a line that appears to be an etched line, without actually etching it, it is possible with the scratch method. The scratch method allows you to quickly produce such a line.

This project follows the idea of applying a transparent wash over paper so that the previously drawn image still appears. The difference now is that the line is scratched into the surface of the paper, not just drawn. And once the applied liquid engulfs and is absorbed into the line, the ink concentrates and the density of ink assumes the character of the broken surface.

The mixture of the ink should be somewhere near the level two on your value scale exercise, or about twenty-five percent of pure black. Practice the mixture of the correct ratio of ink to water. If the mixture is too dark, the image will not be sufficiently contrasted to the background and will be difficult to read.

Begin by doing a light pencil line drawing. After this, the drawn image can be scratched with a sharp tool. The image will emerge after the application of the ink. After the ink dries, the pencil lines can be erased. Applications of the concept behind this approach relates closely to those of achieving textural effects with other media. Wood, for example, can be scratched and then have stain applied to it in order to achieve a desired effect. To achieve linear textured effects on a gessoed surface in painting, the process is the same.

A different idea that may prove interesting, is to scratch a drawing on a 1/8" Plexiglas surface. Then a dark value pigment can be rubbed into the scratches and then the excess pigment can be cleaned off. A lighter valued acrylic color can finally be painted over the whole surface. The Plexiglas then can be turned to reveal the image on the back, a dark line drawing on a light colored background.

Select an object and draw it on a thick paper, like Bristol paper, and attempt this project. More than several efforts may be necessary to gain control of the depth of the scratched line and of the mixture of thinned ink or pigment that works best.

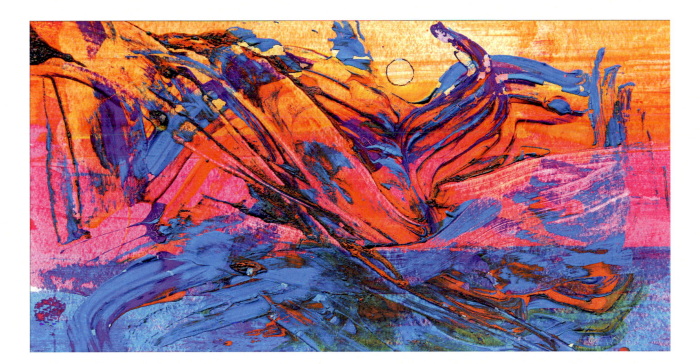

Masking & Resist Technique

The lesson in this project will enable you to:

- Experience control of a unique process.
- Experience expressive possibilities with resist.

With this next exercise, we take the surprise element to another level. The creation of a work that requires several levels of media can be intimidating to most beginning students. However, when confronted with the possibility of a positive and potentially beautiful discovery, it encourages one to further inquiry and focused involvement.

But what is this process? It is a form of cover-up, of masking a surface and altering images to then be able to uncover a new meaning in the process. Complicated? Certainly not. It will require an idea for an image. Once the image is chosen and drawn, various intense colors are applied with oil pastel or wax pigment crayons to the drawn image.

The drawing need not be too specific. A brush, 1" or 2" wide, is then loaded with India-permanent ink, and generously applied over all the colorful wax image, and extending a little beyond its borders. Immediately, the ink will begin to resist the wax, and the painted image will disappear. The new image will appear with broken textured color contrasted against a solid black background. The image may be acceptable as it appears or, after it dries, it can be altered. The alteration can be done by the use of a flat one-sided razor blade. The blade is positioned perpendicular to the surface of the paper and with a little pressure the blade is dragged over the image. The ink and some of the wax will be removed, revealing the intense pure colors that were covered with the ink. Some of the dark ink will remain, but the new mixture of intensity and darkness is usually very stunning. All the image can be revealed or you may choose to take out only certain sections.

An equally interesting procedure is using rubber cement. Again, draw an image lightly with pencil. Next apply some bright colors with wax crayons using only line to describe the object. Now apply rubber cement where you wish to see light values in the form. After this dries, generously apply India-permanent ink to the drawing and beyond to give it a border. The rubber cement and crayons will resist the ink. The effect will be novel and different. After the image is dry, you may remove some or all of the rubber cement.

An application of the idea behind this exercise is done in other media. In painting, for example, any blocking agent can be used to cover a previously painted surface. Tapes of various widths or masking films can be attached to a surface design and painted over. This can be done multiple times to create an overlapping or transitioning of lines or forms in a composition. Multiple pigment applications can be painted over a surface with even fifteen layers of paint, and then scratched, scraped, or sanded to reveal the color and textured image underneath. Textured approaches like this are used to distress antique furniture. In bronze sculpture, patinas are the result of heat and the application of a green oxidizing coating. The artist Leon Golub used the layering and removing of pigments, an additive and subtractive approach, to accomplish a broken surface in his politically expressive works. Attempt at least three of these projects.

Examples of Masking & Resist

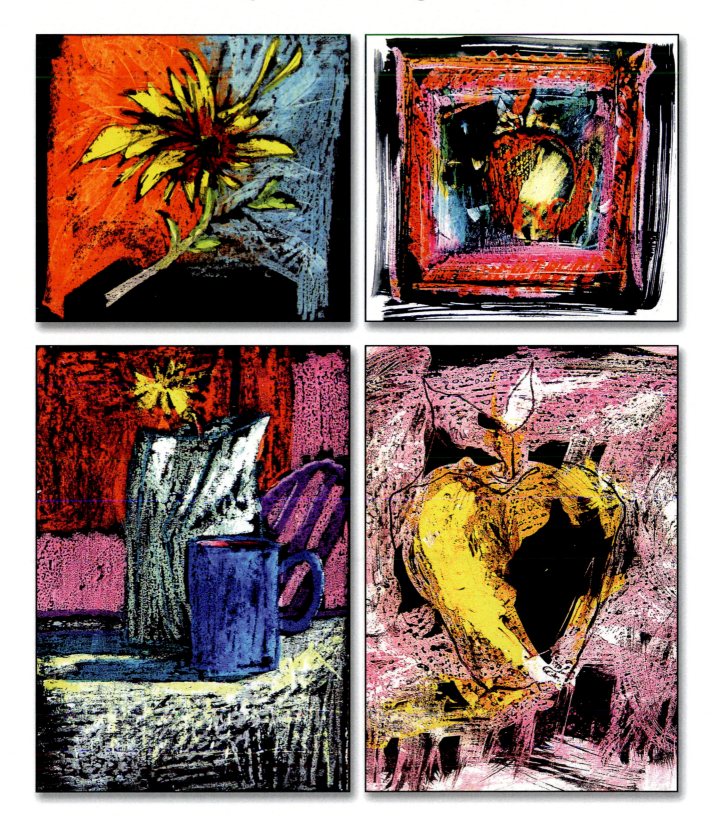

Section VI: Mixed Media & Collage

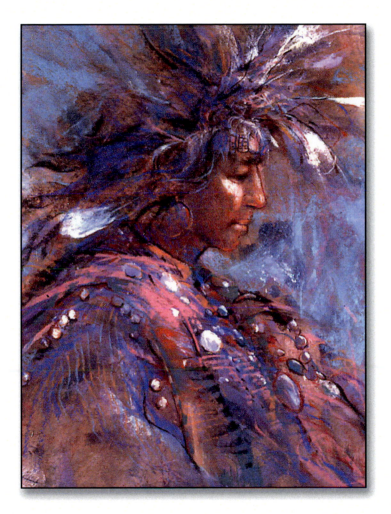

Mixed Media & Collage

Going Beyond with Technique

You've finally reached the final exercise of this book. Using everything you have learned, you are now on your own to combine all the techniques and different forms of media to create pieces of work. You may also feel like diving into collage to create abstract pieces of work.

Congratulations on making it this far!

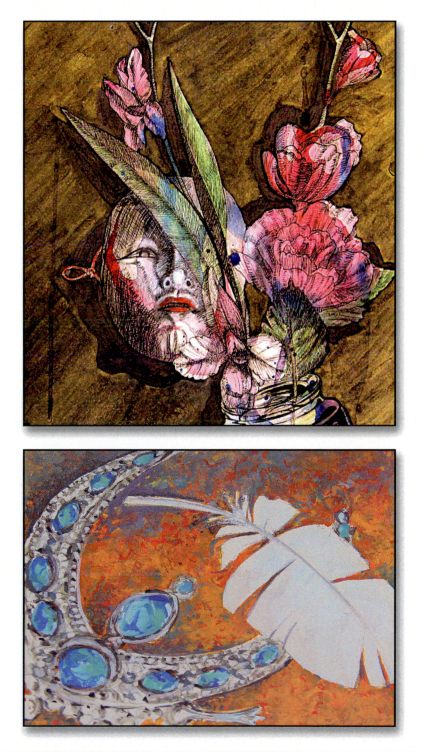

Examples of Mixed Media & Collage

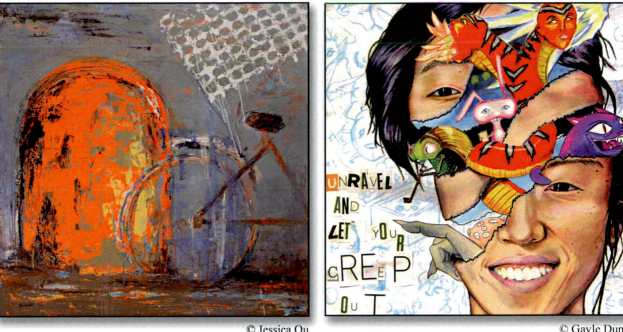

© Jessica Qu

© Gayle Dumm

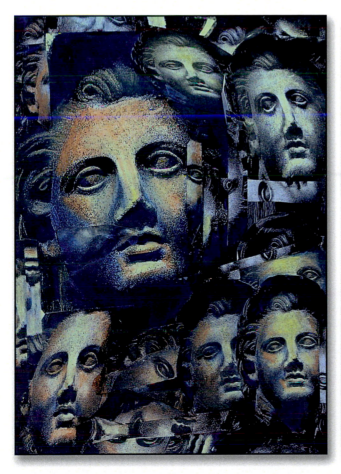

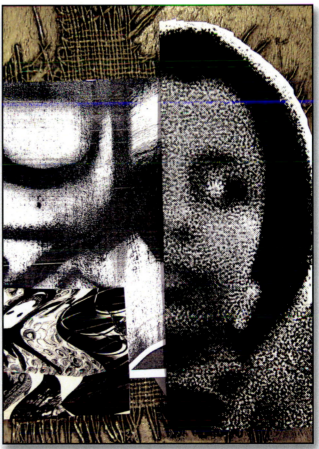

More Examples of Mixed Media

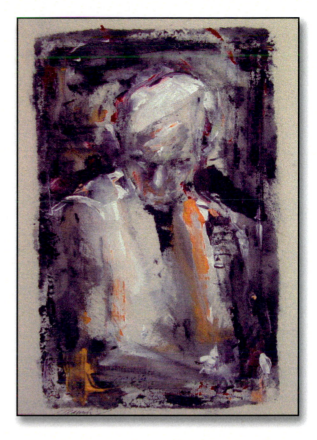

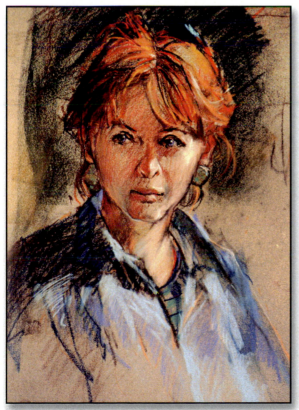

More Examples of Mixed Media

© Bob Saari

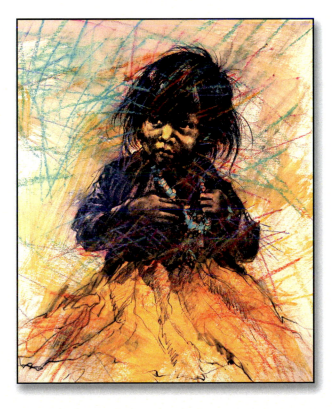

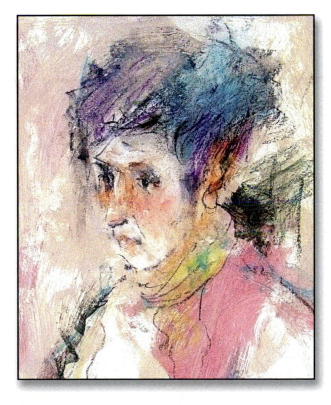

Appendix

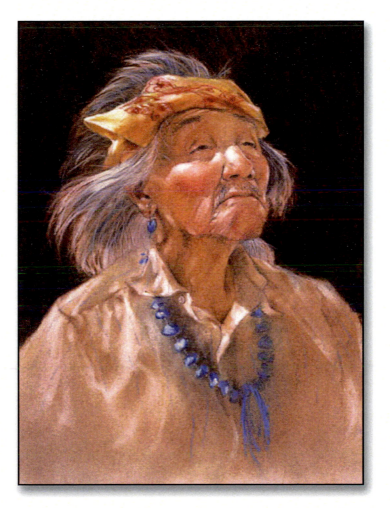

Acronyms & Initialisms

The following are acronyms and initialisms of suggestive steps for learning the theory of drawing.

E.I.I.U.M.I.E.A.

Engage
As in any activity to ensure ultimate success an art student must be given to involvement at a high level.

Isolate
Drawing forms in a usually complex surrounding, involves the separation of subject or object from its surroundings.

Identify
Visually interpreting what we see can be done with greater facility if a student can categorize with some simple measure, the forms they observe.

Understand
Once the form connections have been made, an artist can now focus on rendering them.

Manipulate
After understanding what is observed, a student can proceed in altering or modifying the drawing to interpret what they see.

Integrate
The student can determine at this point what portions of the image satisfy the purpose of their intentions.

Evaluate
Having satisfied the drawing at this step, a student can reflect on the success of the drawing and is now ready to move to the final step.

Articulate
The final step is the communication by the student regarding the effort that transpired in creating the art piece.

P.A.L.M.S.

A general overview of the drawing activity is explained in the acronym of PALMS.

Planes
When forms are observed in nature they are composed of planes, flat or curved, or the combination of both.

Artist
Each artist comes to the drawing experience with preset ideas, levels of experience, and awareness of art. Drawing exercises afford them opportunities to enhance their visual experience and improve the level of awareness, of forms and further their appreciation of those forms.

Light
An artist perceives forms revealed by the presence of light. Light allows the appearance of forms to emerge out of darkness.

Media
The drawing process or mark making is accomplished with the means of media, whether it be a pencil or a stick dipped in ink.

Structure
The observed form in the presence of light can be categorized into basic form structures.

Au.Su.M. *(Assume)*

Axis
The axis or the angle of the directional force of the form in space. Students are to consider the linking of this angle to the "clock face" reference idea.

Shape
The apparent silhouette or structural 'symbol shape' of a form in space. This is a two-dimensional focus as opposed to a three dimensional "volume" reference.

Mass
Adding light to a form defines the value segments or planes of that form in space. And adding the correct value/color contrast to the planes results in the appearance of a three-dimensional illusion of form.

S.L.I.P.

Structures can be categorized into basic shapes and forms. That are either two dimension or three dimensional. Shapes are two dimensional forms and forms are three dimensional shapes.

Solid
There are forms in nature that do not have a volume. They are flat shapes. Forms appear where light exist to bring the appearance of the light, gray, and dark planes of the structure.

Linear
Objects that are transparent fit the category of linear. They are drawn using line to define the front and back of the form. An example would be a cube of ice or a square of jello.

Implied
Some structures are not solid or linear, but their surface planes are broken. An example would be a sponge, a hedge, or a head of hair.

Planar
Structures are identified by the fact that the outside and the inside of the form is observed at the same time.

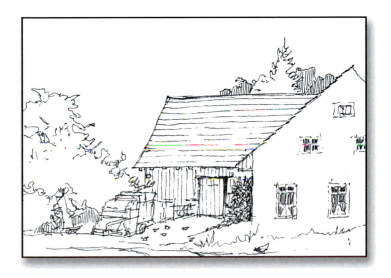

A.I.C.C.

The various characteristics of light can help us understand how illumination explains form.

Angle
The impact of angle or direction of light affects the internal shadows in the form and the cast shadows away form the form.

Intensity
The brilliance of the light impacts the perceived clarity of forms, in terms of value contrast and color. The brighter the light the clearer the perception.

Closeness
The characteristics of forms is more obvious when the form is near to the light source.

Character
The surface appearance of form, whether rough, smooth, or reflective are revealed by light.

W.L.W.S.C.A.V.A.S.C.A.V.W.U.F.

With Light We See Color And Value And Seeing Color And Value We Understand Form

Artist Reference

MEDIEVAL (400-1400)

- **BYZANTINE (500-1400)** The church was the sole patron of art and dictated the art style of the time. Decoration and an interest in the Eastern focus on pattern and embellishment in mosaics was quite evident. Ref. Hagia Sopia.

- **GOTHIC (1100-1400)** A time of the building of many churches embellished with sculpture. The significant form of painting was manuscripts. Ref. Giotto and Cimabue.

RENAISSANCE (1400-1600)

- **ITALIAN RENAISSANCE (1400-1527)** A time that reflected a return to the idealized beauty of the Romans and Greeks. The importance of the individual and an interest in the structure and meaning of every aspect of the world that influenced man. Ref. Masaccio, Giorgione, Titian, Michelangelo, Da Vinci, Uccello Raphael, and Botticelli.

- **NORTHERN RENAISSANCE (1400-1600)** Religion continued to dictate the center of art. Individualism still a strong focus in a time of prosperity through commerce and trade. Art was characterized by love of detail and natural elements. Ref. Van Eyck, Bosch, Bruegel, Durer, Holbein.

- **MANNERISM (1527-1600)** A time of crisis in Italy: Spanish and French invade Italy; the stability of the structure of the Renaissance is broken; religion, politics and the economy have dramatic change - Protestant Reformation and the Jesuit counter reformation; Art reflects the confusion and instability in distorted and exaggerated and transcendent imagery. Ref. El Greco, Tintoretto.

BAROQUE (1600-1750)

- **CATHOLIC BAROQUE** - France, Spain, Flanders, Italy. The aristocracy and the church remain the major patrons of art. Monarchies ruled supreme with Rome as center of church authority. The art reflected this change in religion, classic mythology and aristocratic images. Ref. Caravaggio, Gentileschi, Velazquez, Poussin.

- **PROTESTANT BAROQUE** - Netherlands. The victory of the revolt against the Spanish and the Catholic church allowed the Netherlands (Northern Flanders) to become independent and Protestant. The art reflected a focus on detailed naturalism of daily life along with landscape and portrait. Ref. Rembrandt, Vermeer, Frans Hals.

ROCOCO (1750-1800) France, Italy, and Germany

- The shift of the center for art went from Italy to France. Art work commissioned by the court was characterized by frivolousness, superficiality of images, mythology, and idealized forms. Ref. Fragonard, Boucher, Tiepolo.

19TH CENTURY STYLES

- **NEOCLASSICISM (1780-1820)** France, England, U.S.A. Allegorical focus regarding the French revolution, characterized by Classical themes and a return in an interest in Greco-Roman styles. Ref. David, Ingres.

- **ROMANTICISM (1820-1850)** France, Germany, and England. An opposition to the rigid and concise character of the classical style, reflected in art work of "violence" and "nostalgia." Non-typical color and dramatic compositions were used in landscape and historical themes. Ref. Delacroix, Gericault, Turner, Constable.

- **REALISM (1850-1870)** France. The art reflected a rejection of the previous classical and romantic elements impacted by the accelerating force of the French middle class. The focus was on daily life with all the conflicting social upheavals of the time. Ref. Daumier, Corot, Millet, Manet, Courbet.

- **IMPRESSIONISM (1865-1900)** France. Realism continues as subject matter. The change of focus is on light and how the effect of outdoor light can be reproduced with broken color. Ref. Monet, Renoir, Van Goh (Post Impressionist).

- **ART NOUVEAU (1890-1910)** Europe. A reactionary art against the machine that was principally used in functional art and commercial design. Embellishment and curving organic lines characterized this art. Ref. Lautrec, Beardsley.

20TH CENTURY STYLES

- **EXPRESSIONISM (1900-1930)** Northern Europe, Norway Russia, Germany. Emotional inner-world work was a strong influence in art. Strong interest in psychology. Ref. Kandinsky, Munch.

- **SURREALISM (1920-1940)** The art of the unconscious mind and the dream world. The focus was on realism with illusions of visions of bizarre association and juxtaposition. Ref. Dali, Magritte, Chagall.

- **FAUVISM (1920-1950)** France. Art characterized by flat, decorative, and clashing color. Ref. Matisse, Derain.

- **DE STIJL AND PURISM (1920-1940)** Netherlands. The character of the art was represented by limited color, non-objectivity with line and form creating the total spatial balance. Ref. Mondrian.

- **DADA (1920-Present)** Non-art movement that focused on the break away from all tradition. The individualism of the artist is the vital factor in this work. Ref. Switters, Duchamp.

- **CUBISM (1910-1940)** Work characterized by abstracted geometric shapes representing the multiple views of the objects depicted. Ref. Picasso, Gris, Davis.

- **FUTURISM (1910-1940)** The influence of the motion-picture is evident. Work characterized by broken, fractured moving forms. Ref. Severini, Boccioni.

- **ABSTRACT EXPRESSIONISM (1950-1960)** U.S.A. Artists worked from a spontaneous and intuitive basis, influenced by Surrealism and Freud. Ref. De Kooning, Pollock, Rothko.

- **POP ART (1960-Present)** U.S.A. The art reflects the idealization of commercially produced products. Mass media is put in new contexts. Ref. Oldenburg, Keinholz, Warhol, Rauschenberg.

- **GEOMETRIC FORMALISTS (1960- Present)** Cerebral, controlled, precise and hard edged, exploitation of space, large scale. Ref. Kelly, Stella.

- **SUPER-REALIST, PHOTO-REALIST (1970-Present)** U.S.A. Art and technology. Photographically referenced immaculate and precise in execution. Ref. Estes, Hanson.

- **CONCEPTUAL ART (1960- Present)** Art of the Idea. The concept is the most significant factor. Intuition, novel juxtaposition of image, subject matter, thoughts, experience, performance and communication - the process at times more important than the end result.

- **POST MODERN ART AND CURRENT** Go online and research current changing art trends.

Bibliography

Betti, Claudia, and Teel Sale. *Drawing: A Contemporary Approach.* 6th ed. Belmont, CA: Wadsworth Publishing, 2007.

Bridgeman, George. *Bridgeman's Guide to Complete Drawing from Life.* Random House, 1992

Brown, Clint and Cheryl McLean. *Drawing from Life.* 3rd ed. Belmont, CA: Wadsworth Publishing, 2003.

Canaday, John. *What is Art? An Introduction to Painting, Sculpture, and Architecture.* New York: Random House, Alfred A Knopf, 1980.

Chaet, Bernard. *The Art of Drawing.* 3rd ed. New York: Holt, Rinehart, & Winston, 1983.

Chaet, Bernard. *An Artist's Notebook: Techniques and Materials.* New York: Holt, Rinehart, & Winston, 1979.

Edwards, Betty. *Drawing on the Right Side of the Brain.* Los Angeles: Houghton Mifflin Co., J.P. Tarcher, 1979.

Enstice, Wayne, and Melody Peters. *Drawing: Space, Form, Expression.* 3rd ed. Englewood Cliffs, NJ: Prentice Hall, 2003.

Gofrey, Tony. *Drawing Today: Draughtsman in the Eighties.* Oxford: Phaidon. 1990.

Goldstein, Nathan. *The Art of Responsive Drawing.* 4th ed. Prentice Hall, Inc., A Simon and Schuster Co., 1992.

Henning, Fritz. *Concept and Composition: The Basics of Successful Art.* Fairfield, Conn.: F&W Publications, North Light Books, 1983.

Henri, Robert. *The Art of Spirit.* Edited by Margery A. Ryerson. Haper & Row, Publishers, 1984.

Henning, Fritz. *Drawing and Painting with Ink.* Cincinnati, OH: North Light Publishing, 1986.

James, Jane H. *Perspective Drawing: A Directed Drawing.* Englewood Cliffs, NJ: Prentice Hall, 1981.

Kaupelis, Robert. *Experimental Drawing.* Watson-Guptill Publications, 1980.

Laliberte, Norman and Mogelon, Alex. *Drawing with Ink - History and Modern Techniques.* Art Horizons, Inc., 1970.

Mendelowitz, Daniel M., David L. Faber, and Duane A. Wakeham. *A Guide to Drawing.* 7th ed. Belmont, CA: Wadsworth Publishing, 2006.

Montauge, John. *Basic Perspective Drawing: A Visual Guide.* 4th ed. Hoboken, NJ: Wiley Publishing, 2004.

Nicolaides, Kimon. *The Natural Way to Draw: A Working Plan for Art Study.* Boston: Houghton Mifflin Co., 1977.

White, Gwen. *Perspective: A Guide for Artists, Architects, and Designers.* Applicationington DC: Batsford, 2004.

Conclusion

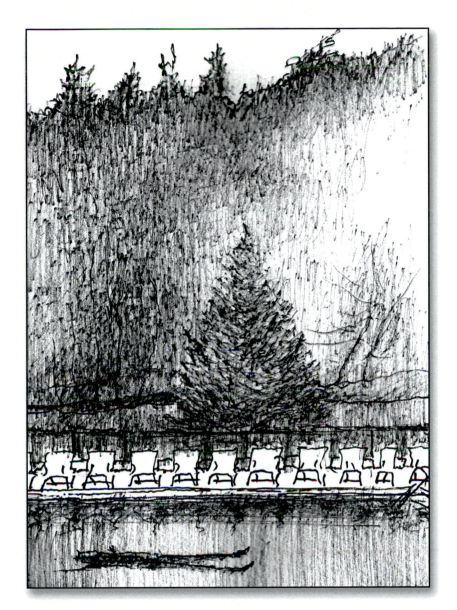

I genuinely hope this book has provided the foundational information that will enable you to continue to progress in your drawing efforts, and that you have understood the importance of the basics in art expression. It is always an encouragement to see the improvement students make and the commitment and diligence they demonstrate in mastering art principles through the completion of the workbook exercises.

It is my hope that you will grow even further, continuing to explore all the vast possibilities in drawing, and other artistic vehicles of expression. And, as you continue to create art, I know you will feel the joy in sharing your art with others. However, regardless of whether you continue in art or not, I hope that you will reflect positively on the richness of the art experience provided to you by the information that was given you in this book.

Finally, remember to be aware of your personal connection within the vast history of artistic expression. "Mark Making" is now a part of your life! It will continue to impact you and your world.

Do not hesitate to allow me to be of some assistance to you in the future...

- Mr. "Z"

About the Author

Frank Zamora began drawing at the age of four, and he continues his love of art. He has exhibted his art as a professional artist and educator for over five decades. He received his education at the Claremont Colleges in Southern California, and graduate studies at Claremont Graduate School and the University of California, Davis.

His works are included in numerous private collections. And, his work has received national exposure at numerous galleries in Los Angeles and Orange County, California. Additionally, his work has been included in Southwest Magazine.

Although his work is diverse as is his interest in various art approaches and disciplines, his style of art may be labelled "Creative Painterly Drawings".

He is the author of two workbooks, "Marking Your World", a drawing guide for beginning students and "Designing Your World", a theory of design book.

"Success in all my work could never have been accomplished without the gifts that I was given, 'To God be the Glory'".